DALÍ

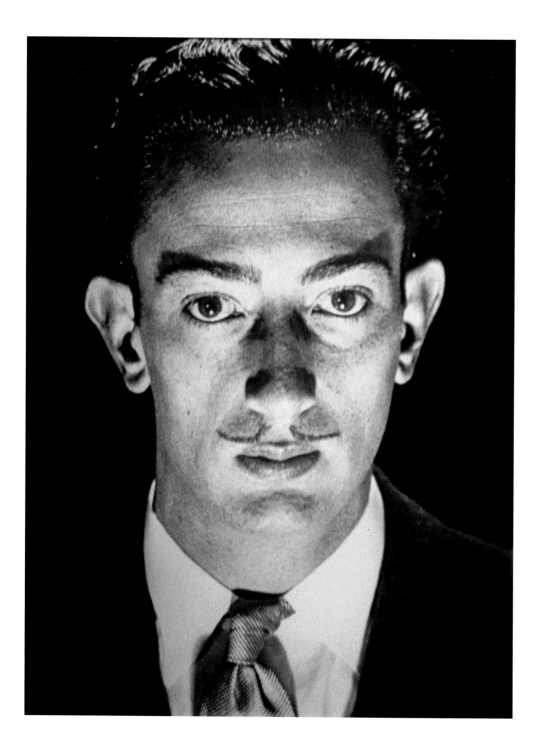

MASTERS OF ART

DALÍ

Alexander Adams

PRESTEL

Munich · London · New York

Front Cover: *Enigma of Desire or My Mother, My Mother, My Mother*, 1929, Bayerische Staatsgemäldesammlungen, Sammlung Moderne Kunst, Pinakothek der Moderne, Munich (detail, see page 57)

Frontispiece: Man Ray, *Portrait of Salvador Dalí*, 1929, © Man Ray 2015 Trust / VG Bild-Kunst, Bonn 2023
pages 8/9: Teatre-Museu Dalí, Figueres, 2010, Catherine Bibollet (detail, see pages 34/35)
pages 38/39: *The Persistence of Memory*, 1931 (detail, see page 61)

© Prestel Verlag, Munich · London · New York 2023
A member of Penguin Random House Verlagsgruppe GmbH
Neumarkter Strasse 28 · 81673 Munich

Artworks by Salvador Dalí: © Fundació Gala-Salvador Dalí, VG Bild-Kunst, Bonn 2023

A CIP catalogue record for this book is available from the British Library.

Editorial direction, Prestel: Anja Besserer
Copyediting and proofreading: Vanessa Magson-Mann, So to Speak, Icking
Production management: Andrea Cobré
Design: Florian Frohnholzer, Sofarobotnik
Typesetting: ew print & media service gmbh
Separations: Reproline mediateam
Printing and binding: Litotipografia Alcione, Lavis
Typeface: Cera Pro
Paper: 150 g/m² Profisilk

MIX
Paper | Supporting responsible forestry
FSC® C021956

Penguin Random House Verlagsgruppe FSC® N001967

Printed in Italy

ISBN 978-3-7913-8737-6

www.prestel.com

CONTENTS

INTRODUCTION

When interviewed in 1928 on his aims, the youthful Salvador Dalí announced: "First, the only moral aim is to be true to the reality of my inner life; the second, my deepest purpose in art is to contribute to the extinction of the artistic phenomenon and to acquire international prestige; third, my definitive aspiration is always to express an alive state of mind."

We think we know Salvador Dalí—with his distinctive moustache, bold stare, flamboyant clothing and outrageous pronouncements—yet the real Dalí is rather stranger than that. Dalí, supporter of Generalissimo Franco, the Spanish monarchy and Catholic church, began as a Communist. He was an anarchistic anti-theist committed to tearing down institutions. When Dalí said he wanted to end "artistic phenomenon", he was not joking. He wanted to make art so radical it would forestall the possibilities of extending tradition and maintaining a distinction between art and everyday life. He would propose Surrealist sculptures that would be anti-sculptural, made of ordinary objects recombined. He had plans to make cinema that would stimulate all the senses.

Yet Dalí did not subscribe to Josef Beuys's dictum "Everybody is an artist". Dalí (even as an anarchist) was never an egalitarian; he was an imperious aristocrat. "Each morning when I awake, I experience again a supreme pleasure—that of being Salvador Dalí." He was an extreme egoist who felt shame and also devoted his life and art to glorifying his wife, Gala.

For the public, Salvador Dalí is the quintessential Surrealist. When Dalí declared "I am Surrealism", the world largely took him at his word. He was a member of the Surrealist group between 1929 and 1939 and affiliated with the group for longer. He is the Surrealist who best recorded the weird, dreamlike, uncanny and grotesque, and whose art transports us to an immediately recognisable (and disconcerting) world. Of all Surrealist artists, he is one who most thoroughly read and thought about Sigmund Freud's theories of libido, ego, dreams and the subconscious. He is the only Surrealist artist who met Freud in person.

Yet, in some respects, Dalí was not a typical Surrealist, perhaps understandably so considering his individualism. The Surrealists were worried that his obsessions were too extreme and his pictures too explicit, even before he officially joined the movement. When he was officially expelled from the Paris Surrealist group by its leader André Breton in 1939, it was due to Dalí's politics. In truth, Dalí was

too eccentric and too shocking for the Surrealists. His art dwelt in troubling and explicit areas: masturbation, sodomy, coprophilia, incest, impotence, cannibalism, putrefaction, blasphemy, disfigurement, death. Even for a group dedicated to overturning the norms of bourgeois society, Dalí went too far and delved too deeply. His art still disturbs.

Mention Dalí to an art lover and you are likely to get a positive reaction, at least regarding the power of his imagery and the brilliance of his technique; yet reactions from critics and historians are often negative. Dalí has been repeatedly dismissed on many grounds, with more than a hint of snobbery. Dalí's attachment to high Catholicism and adulation of academic painting puts him out of step with the tides of history; his fascination with Hitler, support for Franco and attachment to hierarchy of all kinds leave mainstream commentators suspicious or hostile. There are charges of commercialism, repetition, banality, kitsch and puerility that are difficult to refute. Many of these points Dalí himself conceded, even celebrated. It is undeniable that greed led Dalí to debase himself and those around him. This character flaw led to the forgery of prints on a massive scale, fuelled by blank sheets that the artist had signed for cash.

However, the critical tide seems to be turning. In the last two decades, a wave of academic and archival research has re-examined Surrealism. Dalí has been claimed by performance artists and Post-Modernists, by classical painters and supporters of Bad Art. Dalí's work as an author (of fiction and non-fiction) and activities in cinema, photography, ballet and fashion are being reassessed through fresh eyes. Although critics have asserted he misused his talents, few deny that Dalí was hugely gifted. He created a pictorial world that is enduring and captivating. It gets into our imaginations and under our skin, overturning assumptions about what art is and taste ought to be. Dalí's achievements are unique and no excuse is needed to look at and immerse ourselves within his remarkable art once again.

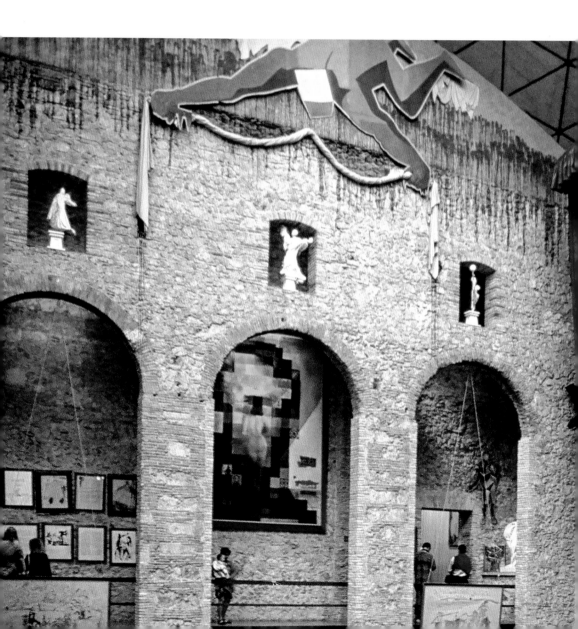

LIFE

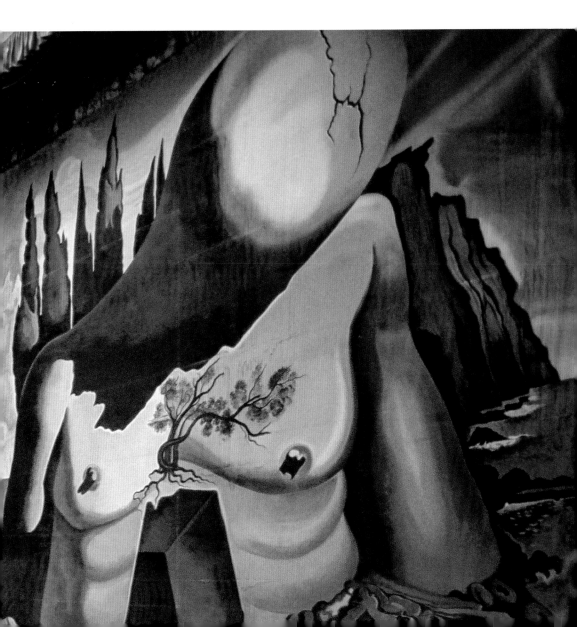

The art and character of Salvador Dalí are inextricably tied to Catalonia and the region of Empordà (Ampurias), a plain abutting the Pyrenees, near the French border. (In this book, Catalan spellings for place names are used, indicating common Spanish (Castilian) ones on their first appearance. Spanish spellings will be found in older books.)

In 1900, a young Catalan named Salvador Dalí Cusí (1872–1950) was awarded the status of notary and returned from Barcelona to live in Figueres (Figueras), regional administrative centre of Alt Empordà. That year, livelihood established, he married Felipa Domènech Ferrés (1874–1921). Their first son, Salvador, was born in 1901 and died in 1903. Nine months later, on 11 May 1904, the future artist, Salvador Felipe Jacinto Dalí was born in Figueres. Four years later a sister—Anna Maria (1908–1990)—was born. The family would buy a holiday home in Cadaqués, Dalí senior's birthplace. Young Salvador was given a traditional education and did well, despite being spoiled and badly behaved. He was also socially timid, incapable of handling money (his sister had to do it for him) and had a paralysing fear of grasshoppers. His strong aversions and erratic temper were indulged by the family. The tale of the madness and suicide of his paternal grandfather troubled Dalí, who feared for his own sanity.

The boy took up painting, making small landscapes. Molí de la Torre (Mill Tower) near Figueres was a property owned by the Pichot family. (The Pichots are discussed on page 40.) As a guest of the Pichots, adolescent Dalí would climb the tower to daydream alone, plotting a

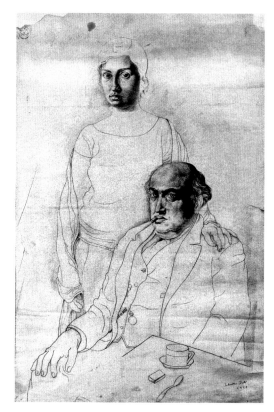

Portrait of Anna Maria Dalí and her father, 1925

road to fame and indulging sexual fantasies. He painted Impressionist pictures in the grounds of the Pichot property. In his diary, Dalí wrote, "This morning I painted the geese, under the

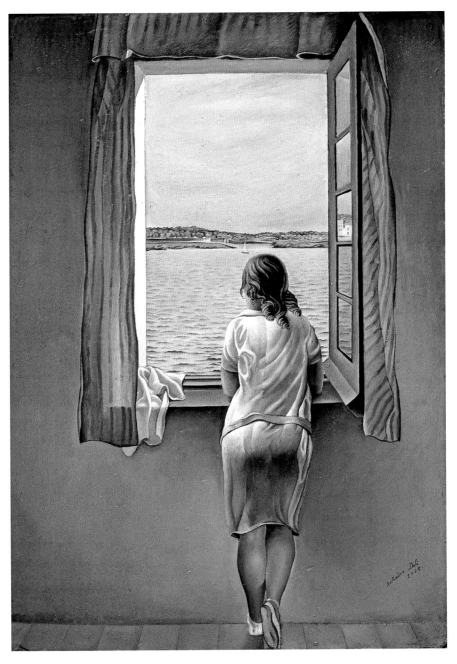

Figure at a Window, 1925

cherry-tree, and I've learnt quite a lot about how to do trees, but what I like best are the sunsets, that's when I really like to paint, using the cadmium straight from the tube to edge the mauve and blue clouds, this way they have a thick layer of paint, necessary because it's so difficult to avoid making a sunset look like a tinted print!"

In autumn 1916, Dalí enrolled in drawing classes of Juan Núñez Fernández (1877–1963) at the Figueres Instituto. He was an inspired teacher and his best pupils were devoted to him. He instilled in students a love of the Old Masters and respect for academic technique. As a youth, Dalí formed an attachment to academic painter of mythology William-Adolphe Bouguereau (1825–1905) and Victorian History painter Ernest Meissonier (1815–1891). Over the years, Dalí would work in the styles of Impressionism, Modernismo (Catalan Modernism), Pointillism, Futurism, Purism, Surrealism, classicism, Photorealism and Op art, yet never stopped defending "outmoded" art against Modernist criticism.

Young Dalí supported the Russian Revolution in 1917, as we can see in his adolescent diaries. He continued to voice support for Communism until the early 1930s, when part of the Communist-affiliated Surrealist movement, but this seems to be an attachment to radicalism rather than egalitarianism. The death of Dalí's mother (on 6 February 1921) shocked and outraged the young man. He took it as an affront, later writing, "With my teeth clenched with weeping, I swore to myself that I would snatch my mother from death and destiny with the swords of light that some day would savagely gleam around my glorious name!" In September 1922, Dalí began studying painting at the Real Academia de Bellas Artes de San Fernando, Madrid. He would live at the Residencia de Estudiantes (hall of residence), which had a vibrant social, sporting and cultural life. It was an intellectual hub of Modernism, where Europe's most prominent figures were invited to lecture. At the Residencia, the young painter would meet individuals who helped him overcome timidity and broaden his horizons. The two most important were poet Federico Garcia Lorca (1898–1936) and future film director Luis Buñuel (1900–1983). With others, they formed a loose intellectual vanguard intent on overturning the status quo and achieving glory.

When Dalí first met him, Lorca was already a promising poet attempting to blend a love of Andalusian folk culture with political progressivism and literary Modernism. Lorca (who was homosexual) was smitten by Dalí and wrote a poem to celebrate him. They collaborated on drawings and constantly wrote letters when apart. Before his friends, Lorca used to act out his own death and decay; evoking these performances, Dalí depicted Lorca's severed head with closed eyes as a feature of many pictures in the mid-1920s. Dalí would paint stage sets for the first production of Lorca's play *Mariana Pineda*, in 1927.

In 1923, Dalí was suspended for joining a student protest. Once readmitted, he largely disdained official tuition. Dalí was just as interested in studying Spanish Golden Age painters at the Prado as he was in Modernism to be found in journals. From

1924 to 1926, he alternated between Modernism and classicism-inflected realism, as can be seen in the careful pencil portrait of his father and sister—"one of my most successful of this period" (page 10). Anna-Maria posed for many portraits at this time (page 11). Still-lifes and figure paintings appear alternately in Metaphysical or Purist styles and in classical or Neo-Classical styles. Dalí's radicalism found outlets in switching between anti-traditionalism and anti-Modernism.

Paris-based Surrealist painter Joan Miró (1893–1983) heard about the promising art student through fellow Catalan artists and writers and recommended him to acquaintances. Like Miró, Dalí had an exhibition at Galeries Dalmau, Barcelona, in November 1925. Its critical and financial success explains why Dalí had the confidence to intentionally fail a compulsory oral exam to gain re-entry into the academy (following a second suspension), resulting in definitive expulsion in November 1926.

We should consider the impact of Freud and Surrealism on Dalí. The ideas of Sigmund Freud (1856–1939) greatly influenced science and society in the early twentieth century. His central proposal—that people were driven by unknown subconscious aversions and desires and that conflict between these drives and social constraints caused mental dysfunction—seemed to open a window on to the behaviour of human beings. The Surrealist group in Paris, headed by writer André Breton (1896–1966), was formed in 1924 from the remnants of Dada. To replace the nihilism and pranks of Dada, Surrealism was conceived as complete liberation of the psyche, catalysed through art, poetry and events, with Surrealist principles being anti-theism, anti-patriotism, pacifism, libertarianism (even libertinism) and exploration of the unconscious. Freudianism would be its principle analytic tool and Communist revolution would be its goal because economic liberation of the proletariat should be accompanied by psychic liberation. The affiliation of anarchistic Surrealism to authoritarian Communism was doomed; Communists never accepted the complete individual freedom that Surrealists stipulated.

Dalí read Spanish translations of Freud in the mid-1920s, while in Madrid. His egotism and individualism had left him naturally preoccupied with himself; Freudianism allowed him to turn his psyche into his prime topic and Surrealism gave such preoccupations artistic legitimacy. As Dalí was too idiosyncratic, self-absorbed and chaotic to follow any movement, his relationship with the Surrealists would be both stimulating and tumultuous. It is fair to say that (in spirit) Dalí would remain a Surrealist his whole adult life, notwithstanding later support for Church, crown and tradition.

One sign of Surrealist liberation was the increased sexual content of art Dalí produced in the so-called "Lorca period" of 1925–28. Symbols of a sexual nature (hands, phallic objects, triangles as stand-ins for female genitals) proliferated alongside increased numbers of nudes. Discussions between poet and painter resulted in wild fantasies and exploration of shameful desires and profound fears. Dalí later confessed that Lorca was in love

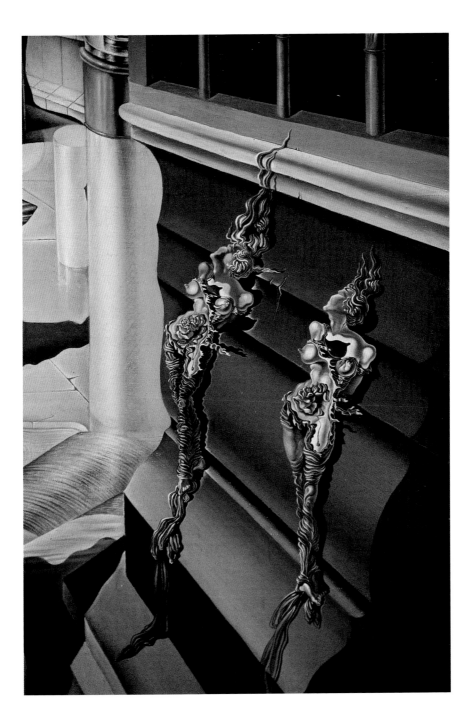

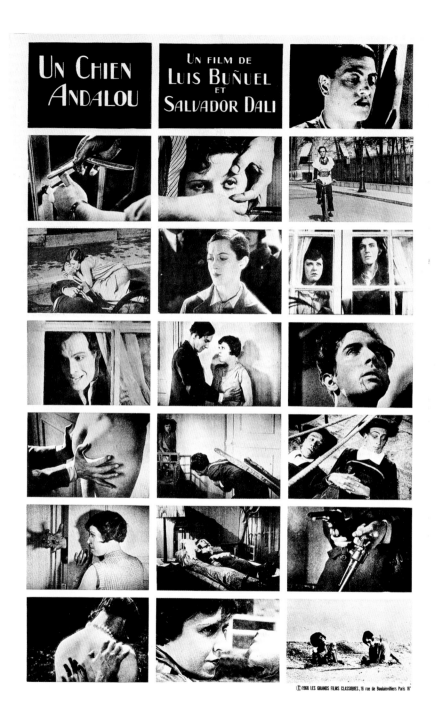

with him but he could not physically reciprocate; their homosocial bond would remain platonic.

In 1926, during his suspension, Dalí made his first visit to Paris. He went to Picasso's studio, with Miró's introduction. Although he did not meet the Surrealists, he did see their art and read their journal and manifesto. Encountering the Metaphysical art of Giorgio de Chirico (1888–1978), as well as the Surreal biomorphic forms by Yves Tanguy (1900–1955) and Jean (Hans) Arp (1886–1966), had a radical impact. Metaphysical Art, which attempted to reveal a hidden deeper reality within scenes that combined ordinary objects and places to atmospheric effect, was a precursor to Surrealist art. At this time, Dalí was writing a lot, mainly reviews and articles on art for Spanish and Catalan journals, but also poems and the Anti-Art Manifesto. The latter was published in March 1928, and viciously lampooned traditionalism in Catalan culture, advocating aggressive Modernism. Despite applying Surrealist techniques as early as 1927, Dalí would not fully commit to Surrealism until 1929.

Over seven days in early 1929, Buñuel and the painter wrote the screenplay for a seventeen-minute-long film, called Un Chien andalou (An Andalusian Dog, 1929). Buñuel was jealous of Lorca's closeness to Dalí and their artistic-literary partnership; the title was interpreted as Buñuel's jibe at the Andalusian Lorca. (Lorca certainly saw it that way.) The film was a sequence of Surrealist scenes, including sexual imagery, a hand crawling with ants and two priests tied to a grand piano stuffed with two rotting donkeys.

The most notorious scene is of a man watching a cloud bisecting a full moon, then falling into a trance before slicing open a woman's eye (simulated). When the film opened on 6 June 1929, it impressed the Surrealists and patrons the Comte and Comtesse de Noailles, who screened the film in their private cinema and agreed to fund the next Dalí-Buñuel production. The two Spaniards decided to make their next film more shocking.

The First Days of Spring was Dalí's first painting of 1929 and inaugurated his classic Surrealist paintings. It was clearer than previous paintings, more detailed (even hyperreal), painted in absolute fidelity using extra-fine sable brushes and incorporated collaged elements. The sharpness of shadows resemble those of de Chirico's twilight scenes, but the light had the unique brilliance of Empordà. The distant horizon and featureless plain would provide the setting for wild fantasies. At this time, Dalí moved to Paris. He signed a contract with dealer Camille Goemans and met Paul Éluard. Dalí went back to Cadaqués for the summer and would habitually divide his years between summer in Spain and winter in Paris.

In the summer of 1929, a fateful event occurred. Visiting Cadaqués were Goemans and his girlfriend Yvonne Bernard, René and Georgette Magritte and Paul and Gala Éluard; later, Buñuel came to work with Dalí on the script for L'Age d'or. Magritte painted; Dalí started a portrait of Éluard; the others dined and sunbathed. Gala, who had perhaps been deputised to curry favour with Dalí so that Éluard could acquire Dalí paintings

Hallucination. Six Images of Lenin on a Grand Piano, 1931

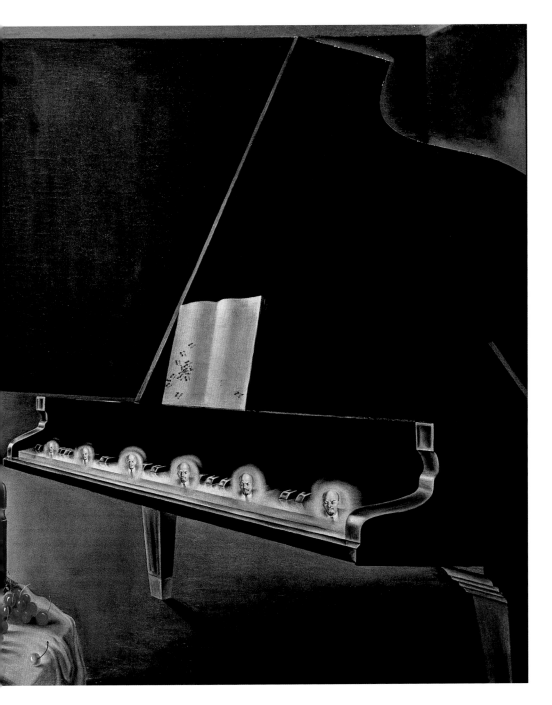

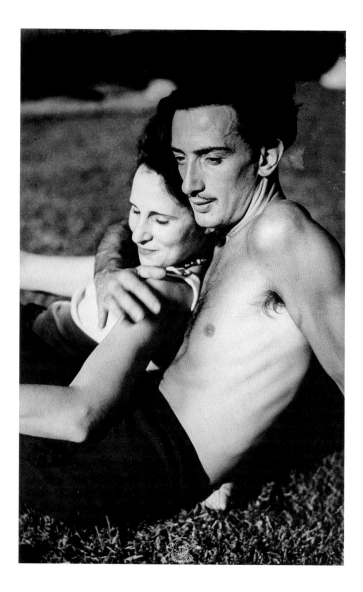

at a discount, began an affair with Dalí. Against all odds, Gala threw in her lot with the eccentric, intense young Catalan. For the rest of their lives, they would remain together. Gala would become the centre of Dalí's world as his lover, muse, publicist and business manager. It was a gamble that paid off, at least materially. Commentators have had divided views about whether Gala was a good influence on Dalí's art. Dalí had no doubt that, without her, he would have ended up a failure or insane. Dalí dedicated his art to her by signing canvases "Gala-Salvador Dalí".

Who was the real Gala? That is difficult to answer. She was famously private, refusing all offers of interviews and publishing nothing. Born Elena Ivanovna Diakanova Devulina (1894–1983), to a middle-class Russian family in Khazan, Gala was sent to a sanatorium in the mountain resort of Davos to avert development of tuberculosis. There she met young poet Éluard, whom she would marry on 20 February 1917, while he was serving in the French army. They were at the centre of the emergent Surrealist group, with Gala's beauty, fierce temper and numerous affairs eliciting attention. Her affairs would continue during her marriage to Dalí.

When he returned to Paris later that year, Dalí produced (using the style of Francis Picabia) an ink drawing of Christ, inscribed with the title *Sometimes I Spit for Pleasure on the Portrait of my Mother* (1929). When he heard of this disrespectful attitude, his father was antagonised. The defamation of his first wife and Dalí's liaison with a married Russian woman proved too much for Dalí senior; in 1930, he disinherited Dalí, broke contact with him and expelled his son from Cadaqués. Dalí and Gala moved around the headland to a fishing village called Portlligat (Port Lligat). They would enter a civil marriage on 30 January 1934 (in Paris), only having a Catholic marriage ceremony on 8 August 1958, near Girona, after Éluard's death.

The Dalís participated fully in the Paris Surrealist group activities, exhibiting together, dining, attending vernissages, parties, séances and so on. Dalí signed collective statements that supported the Parti communiste français, even though his anti-authoritarianism was now psychological in basis, no longer political. He wrote articles that ranged from art criticism to elaborate analyses of his psychological complexes. The Surrealist milieu provided the Dalís with new friends, such as poet René Crevel. Gala's desertion of Éluard caused Éluard sadness rather than bitterness. Breton considered Dalí a useful recruit to the movement, but politically unreliable. However, Dalí had already seen the problem at the heart of Surrealism: its contradictory support for individual absolute freedom whilst serving conformist collectivist Communism.

L'Age d'or—the second and last cinematic collaboration between Buñuel and Dalí—was presented in late 1930. The implied sexual content and mockery of establishment and Church made it more provocative than *Un Chien andalou*. As it was known that Marie-Laure de Noailles (who was Jewish) had financed the film, the rightist ultra-Catholic groups Ligue des Patriotes and

Ligue antisémitique de France saw *L'Age d'or* as a Jewish attack on patriotism. On 3 December 1930, they attacked Studio 28, which was showing the film, damaging Surrealist art in the foyer, including paintings by Dalí. With the film becoming a *cause célèbre* for liberals and reactionaries, the Parisian police acted and banned the film on grounds of blasphemy.

Dalí used the "paranoiac-critical method", which was never properly explained by him. It involved cultivating neuroses, complexes and paranoia that would allow the artist to perceive hitherto hidden connections between apparently unrelated objects and imbue images with disturbing psychological resonance. For example, double images allow two truths to overlap and contradict one another in a single combined image. Such images had been common in popular psychology textbooks and journal puzzle pages since the previous century. Surrealists viewed Giuseppe Arcimboldo (1526/7–1593), who had painted personages composed of fruit and vegetables, as the anticipator of Dalí's double images. In Dalí's case, double images explored his mental landscape, addressing obsessions of sexual explicitness, perversity, horror, death and deformity. The results, including *Partial Hallucination. Six Apparitions of Lenin on a Piano* (pages 18–19) were—as far as convinced Communists were concerned—dangerously politically unorthodox.

Repugnant subjects were made more challenging through their sumptuous execution. Dalí's early Surrealist paintings are usually very small and finely detailed, for which the artist

used a jeweller's eyepiece and fine brushes. Meticulous technique required long sessions and he devoted whole days to continuous painting, six days per week in the early years. This slow pace prompted Gala to found the Zodiac Group. Rich benefactors would contribute to a stipend for the artist; in return they had a monthly dinner and lottery, with the winner awarded the latest Dalí painting, many with comic-baroque titles, such as *Necrophilic Fountain Flowing from a Grand Piano* and *Average Atmopherocephalic Bureaucrat in the Act of Milking a Cranial Harp.*

In 1933, Albert Skira (publisher of luxury art books and print portfolios) commissioned from Dalí forty engravings for an edition of the key Surrealist text, Comte de Lautréamont's *Les Chants de Maldoror* (1868/9). Dalí drew designs but apparently did not engrave them, instead hiring a master engraver to transfer designs to copper plates, as engraving was a time-consuming and difficult practice that Dalí had not mastered (page 24). Dalí's casual attitude towards authenticity and delegation would have serious consequences years later. Illustrations included motifs from Jean-François Millet's *The Angelus* (1857–59), which came to dominate Dalí's pictorial landscape, appearing in numerous pictures in the 1930s, including *Atavism at Twilight* (pages 22–23). Another subject was William Tell, which was a reverse of the Oepidal complex. The William Tell complex is where the father symbolically kills or emasculates the son—an understandable response of a timid son to a domineering father.

Dalí's first visit to Italy (in 1935) precipitated an emulation of Leonardo da Vinci's drawing style and the painterly handling of Tintoretto. Dalí stated that "the Theatre of Palladio in Vicenza is the most mysterious and divine 'aesthetic' spot" that he knew. This was the same year that Dalí and Lorca met again, overcoming the coolness that had developed since the calculated insult of *Un Chien andalou.* The meeting went well and they discussed working together in future. It was not to be. The following year, Lorca was executed by Nationalists during the Civil War.

In May 1936 the Exposition Surréaliste d'Objets opened at Galerie Ratton, Paris, including contributions from Dalí. Since 1931, he had been promoting the creation of Surrealist objects, particularly ones that were not sculptural. *Venus de Milo with Drawers* (1936)—a plaster cast of the statue, fitted with drawers—was an elaboration of the metaphor of personal self-absorption. The same year he produced an oil painting and drawings on the same motif; the illustrated drawing (pages 26–27) shows how accomplished Dalí was as a draughtsman in the Old Master style. The size of paintings increased, as did his production rate, not least because a looser painting style meant he could work faster.

The advent of the 1936–39 Spanish Civil War divided Dalí from the Surrealists, with them supporting the leftist Republicans and Dalí the sole Surrealist favouring Franco, although he kept quiet on the subject until the end of the war. In a 1939 letter to Buñuel, Dalí wrote, "[…] Marxism, philosophically and from every point of view,

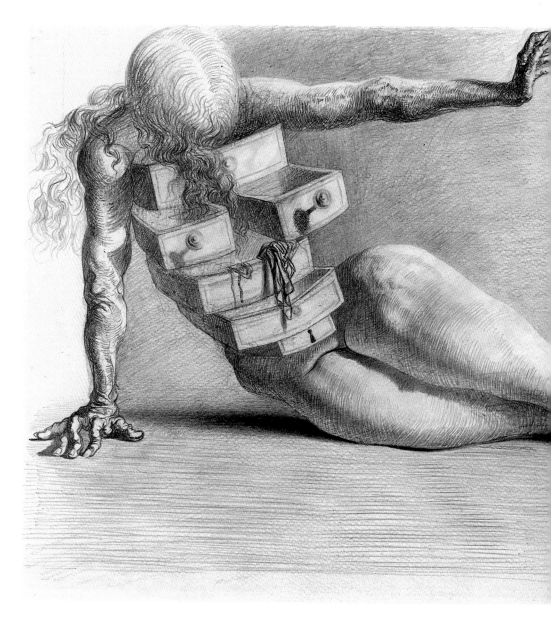

City of Drawers, 1936

Bust of Voltaire, 1941

is the most imbecilic theory of our civilization, it's totally false and Marx is probably the acme of abstraction and stupidity [...]". His break with Communism could not be clearer. At the outbreak of World War II, the Surrealists fled for their lives, many having had their art declared degenerate by the Nazis. Despite admiring Hitler, Dalí could not be sure the admiration would be reciprocated, so he decided to leave Europe. In Arcachon, Dalí spent time playing chess with Marcel Duchamp, as they waited for confirmation that they had tickets for a liner from Lisbon to New York.

From 1940 to 1948, the Dalís lived in the USA, mainly in New York and Monterey, California. He was committed to burying Surrealism, using classical art to replace it. In effect, with much of his activity diverted into filmmaking, publicity and writing, Dalí's production of painting was reduced. When he did paint, it was most often portraits of wealthy individuals with whom the artist had no connection. Apart from a few notable paintings—such as *Dream Caused by the Flight of a Bee around a Pomegranate One Second before Waking* (c. 1944), *Basket of Bread* (1945), *The Temptation of St. Anthony* (1946), *Leda Atomica* (1947–49)—the American years show a dramatic decline in Dalí's painting. For some critics (including Breton), Dalí's decline would be permanent.

The Secret Life of Salvador Dalí (1942) was written by Dalí in the USA. Even though he was separated from sources that would otherwise have made the book more accurate, it is fair to say that fidelity to the truth was not a priority for

Dalí when writing his memoirs. It is highly subjective and designed to perpetuate the myth of the author as child genius, moral leper and saviour of Surrealism, as well as tell the tale of Dalí as star-crossed suitor of the immortal incomparable Gala. It is as entertaining as it is misleading, full of vivid anecdotes and elaborate conceits. It included illustrations in the form of photographs and Dalí's art.

The book contains a photograph of Dalí using a light projector to assist him. "It is quite correct that I have made use of photography throughout my life. I stated years ago that painting is merely photography done by hand, consisting of super-fine images the sole significance of which resides in the fact that they were seen by human eye and recorded by a human hand. Every great work of art that I admire was copied from a photograph. The inventor of magnifying glass [Cornelius Van Drebbel] was born in the same year as Vermeer. Not enough attention has yet been paid to this fact. And I am convinced that Vermeer van Delft used a mirror to view his subjects and make tracings of them."

A photograph of Jean-Antoine Houdon's *Bust of Voltaire* (1778) suggested two women in bonnets (pages 28–29). The cleverness of such double images appealed to the American public, collectors and film makers. Director Alfred Hitchcock invited Dalí to create the dream sequence in *Spellbound* (1946), which used innovative technical methods to achieve the results Dalí stipulated. Dalí conceived, scripted and drew storyboards for *Destino*, in collaboration with Walt Disney. This animated short film preoccupied the artist during 1945/6 but was to remain (apart from a brief sequence) unfinished. The changing market for animated shorts made *Destino* financially unviable and it was shelved indefinitely. This did not impair the cordial relationship between Disney and the painter; Disney came to visit Dalí in Cadaqués. *Destino* was reconstructed and completed in 2003, using Dalí's storyboards. Although Dalí came up with many scripts and projects, after *L'Age d'or* he would complete only one film, as will be discussed later.

The detonation of the nuclear bomb over Hiroshima in August 1945 was portentous for Dalí. A nuclear age would herald a Christian revival, he said, for which he would provide art in a new atomic style. It would feature atomised floating elements, including water skins. Such was its complexity, that in order to design *Leda Atomica* (1947–49), Dalí required assistance from mathematician Matila Ghyka. Once Dalí returned to Spain, assistants contributed to his largest paintings. In terms of time and mental energy, large paintings demand a lot; Dalí was putting most of his effort into drawings and watercolours for book illustrations and portfolios. He delegated to others the transferring compositions and painting of less significant areas of canvases.

By the time he left the USA in 1948, Dalí was hugely famous and fabulously rich, not least due to Gala's guidance. Yet, he had depleted his reputation. Much of his time henceforth would involve lucrative but undemanding mass-media advertisements, endorsements and authorising copies

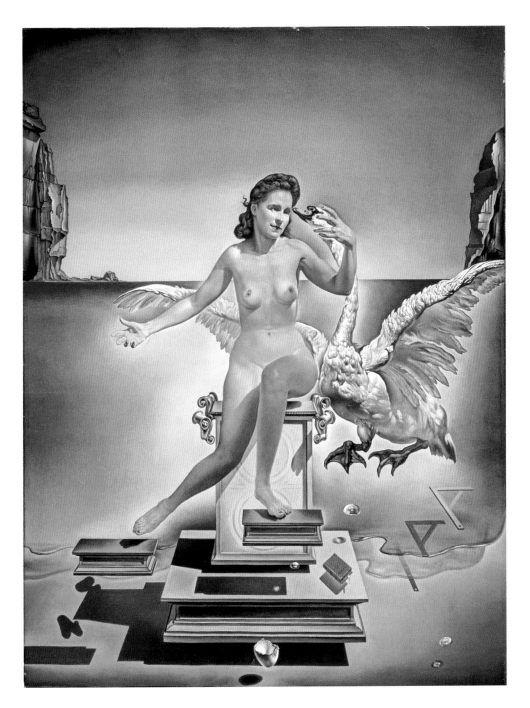

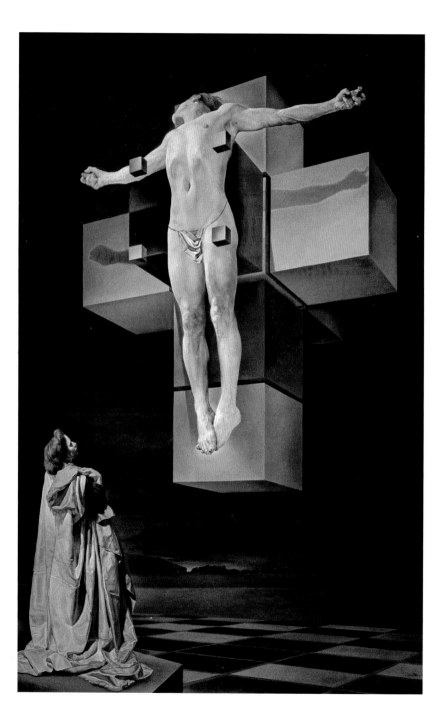

Corpus hipercubus (Based on the treatise on cubic form by Juan de Herrera, builder of the Escorial), c. 1954

of his art. In late July 1948, the Dalís returned to Portlligat to live. They visited Dalí's father and Anna Maria in Cadaqués, only partially mending the breach of 1930. The following year the breach was reopened by Anna Maria's demythologising memoirs of her brother. Dalí's father died on 21 September 1950.

Dalí's nuclear-mystic period began in 1950, with the second version of *The Madonna of Portlligat* (page 99). It differs from the preceding nuclear style only through more explicit links to classical art and the adoption of religious subjects. *Corpus hipercubus* (page 32)—alongside *The Christ of St. John of the Cross* (page 101)—was one of the stronger nuclear-mystic paintings. Dalí painted his last canvas in this style in 1963. The adoption of religious subjects and traditionalism drew scorn from the surviving Surrealists. What were Dalí's politics? We can say that Dalí's taste, politics and personality were firmly reactionary. He declared himself opposed to collectivism and egalitarianism; he sided with the art of the Renaissance and against African tribal art (admired by Picasso and the Surrealists). It is easy to see why Surrealists, Communists and liberals found his statements inflammatory.

Never shy of flaunting opulence, Dalí worked with master jewellers to design wearable and sculptural jewellery. The *Ruby Lips* (1949) brooch is a woman's mouth, with rubies for lips and pearls for teeth. *The Royal Heart* (1953) is a gold heart, surmounted by a crown; inside the heart is a smaller heart of rubies, with a motor inside which causes it to pulse. Similar artistry and

ostentation can be found in *For the Love of God* (2007), a platinum skull encrusted in diamonds, featuring real teeth, made by Damien Hirst (b. 1965). Dalí's jewels are housed in their own museum in Figueres.

The discovery of DNA in 1953—and related presentations of the double-polynucleotide-chain spiral—sparked the painter's imagination. For a time, the nuclear particles that populated his canvases are joined spiral ribbons of molecules. The late 1950s was a time when Op art came to the fore and Dalí (as ever) was quick to notice connections between Op art patterns and his dots, claiming that his inventions had paved the way for the younger painters of dots. Dalí's exact transcriptions of photographic sources—particularly in the still-lifes of the 1950s—presage Photorealism, which became fashionable in the 1960s and 1970s.

In 1969, Dalí bought Gala an abandoned tower in nearby Púbol and renovated it for her. It became her prime residence, with Dalí only admitted by written invitation, which Dalí claimed (as a masochist) to relish. Arranging decoration of Gala's tower and a museum of his art would preoccupy him for years, even if assistants did most of the work. There is a decline in the quality of invention and execution of Dalí's paintings in this period, with his final significant work being an unfinished painting of 1972/3 (page 109).

Teatre-Museu (Teatro-Museo) Dalí, Figueres was intended to be a museum with a unique character. The roofless theatre, which had been burned during the Civil War, would be furnished with

Teatre-Museu Dalí, Figueres, 2010,
Catherine Bibollet. The grey stone
slab on the floor is Dalí's tomb.

reproductions of Dalí's art and left open to the elements. Eventually, Dalí relented and agreed that it should house his personal collection of art, including an academic nude painting by Bouguereau. He devised giant scenic paintings, bizarre combinations of objects and sculptural inventions. One of these was a recreation of *Rainy Taxi* (1938), which inside had mannequins continuously sprinkled with water and covered in snails and leaves. A geodesic dome as a roof and giant models of eggs and Catalan loaves would transform the building's exterior, which opened on 24 September 1974. When Dalí painted now, it was for his museum rather than for sale. In the post-war period, during long stays in Paris and New York Dalí did not paint at all. Lucrative endorsements and advertising became a common distraction, as both corporations and counter-culture coveted Dalí's name.

The artist's devotion to both the Franco regime and Juan Carlos de Borbón (the future king) remained unshakeable. When Dalí made pro-Franco statements after the execution of opponents of the government in 1975, he received death threats. A bomb was planted by terrorists at his favourite restaurant in Barcelona. This left Dalí alarmed and for a time his manager carried a pistol to protect the artist.

Always keeping up with scientific developments, Dalí collaborated with Dennis Gabor (1900–1979), who was awarded the 1971 Nobel Prize for Physics for the invention of holography. Together, they created seven holographs in the 1970s, which can be seen at the Teatre-Museu.

The holograph went beyond the stereoscopic paintings by offering new dimensions in a hyper-precise format that combined science and art.

In 1974 French police intercepted a van containing 40,000 sheets of paper on the Andorran border. The sheets were blank except for Dalí's signature. The police had uncovered a forgery ring enabled by the greed of Dalí and Gala. The number of signed blank sheets was (by some estimates) over a quarter of a million altogether. They were used for commercially printed Dalinian imagery and passed off as original artist's prints. Initially, when confronted with this fraud, Dalí took the faking as a compliment—a sign he was an esteemed emulated artist. Eventually, Dalí was persuaded to denounce the forgeries and (on 1 June 1985) he signed a document condemning forged and fake prints.

Dalí's last film (co-directed by José Montes Baquer), *Impressions de la haute Mongolie. Hommage à Raymond Roussel* (1976), makes extraordinary viewing. This tribute to the French author (much admired by Surrealists) features the painter talking about the quest for a psycho-active mushroom in Mongolia, mixed with montages of his art, the Teatre-Museu and Portlligat home, action scenes and macrophotography of a ballpoint pen that Dalí found in a urinal at the St Regis Hotel, New York. The film (like Dalí's psychedelic last paintings) is influenced by the drug culture of the 1970s. Dalí himself did not take narcotics, declaring, "Take me. I am the drug; take me, I am the hallucinogenic."

Dalí's creative work was at an end. By February 1980, Dalí was experiencing hand tremors so severe that he could no longer paint properly. Although paintings were made in his studio with his approval, these are collaborative pieces and therefore should be viewed as a separate body of art, distinct from the art mainly executed by him personally.

Gala Dalí died on 10 June 1982 and was buried in the crypt of Púbol tower. Dalí's mental state consequently deteriorated. He ceased making art, refused to eat, subsequently losing his voice; he would be fed and hydrated by a nasal tube for the rest of his life, deprived of the pleasures of speech and eating. The king ennobled Dalí as Marqués de Dalí de Púbol on 20 July 1982. Following being seriously burned in a fire in 1984, the frail Dalí lived out his last years in an apartment at the Teatre-Museu, bedbound. He died in Figueres hospital of heart failure on 23 January 1989 and was buried in his museum, contrary to his previously stated wish to be interred next to Gala.

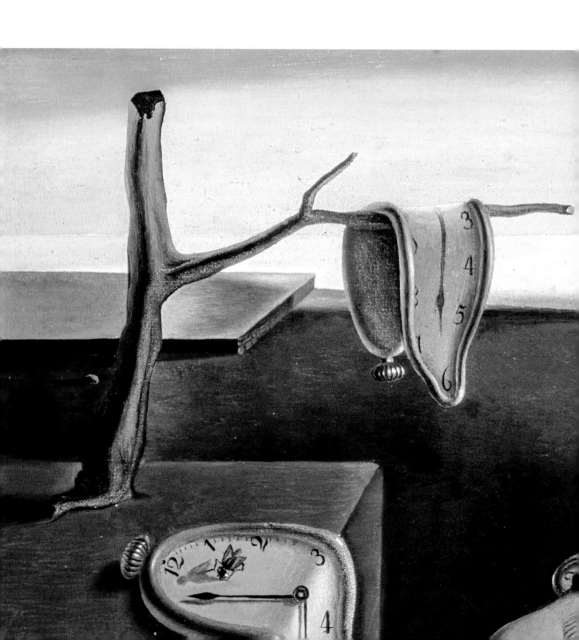

WORKS

Portrait of the Cellist Ricard Pichot, 1920

Oil on canvas
61.5 × 50 cm
Fundació Gala-Salvador Dalí, Figueres

This portrait is of Ricard Pichot, part of the prominent family known for their creative accomplishment in literature, painting and music. The Pichots (like the Dalís) lived in Figueres and Cadaqués. Ramón Pichot (1871–1925) was a talented Impressionist painter, whose example and conversation introduced the youthful Dalí to modern painting. His wife was Laure "Germaine" Gargallo, who had a doomed relationship with Catalan painter Carlos Casegemas—whose suicide supposedly inspired his friend Picasso's Blue period. During a stay in Cadaqués in the summer of 1910, Picasso produced his most abstract and complex Cubist pictures. There is a possibility that the six-year-old Dalí may have encountered Picasso then, although there is no record of a meeting. Ramón's sudden death inspired Picasso's convulsive masterpiece *The Three Dancers* (1925).

Ricard and his brother and sister were all professional musicians. It was during Ricard's practice sessions that the young painter tested out Ramón's Impressionist technique in this portrait. It shows impressive sensitivity to light and atmospheric coloration. Although Impressionism would be a passing phase for the painter, Dalí would display a unique command of colour throughout his career.

In later years, Dalí expressed gratitude for the exposure to art, music and cultural discussion during his formative years. The Pichots gave Dalí the idea that art could be both vocation and livelihood and they persuaded Dalí's reluctant father that his son should attend the academy in Madrid. Memories of the Pichots' Molí de la Torre was a central part of Dalí's mental landscape. Ricard's son Antoni Pitxot would become Dalí's assistant, confidante and helper from 1972 until the master's death.

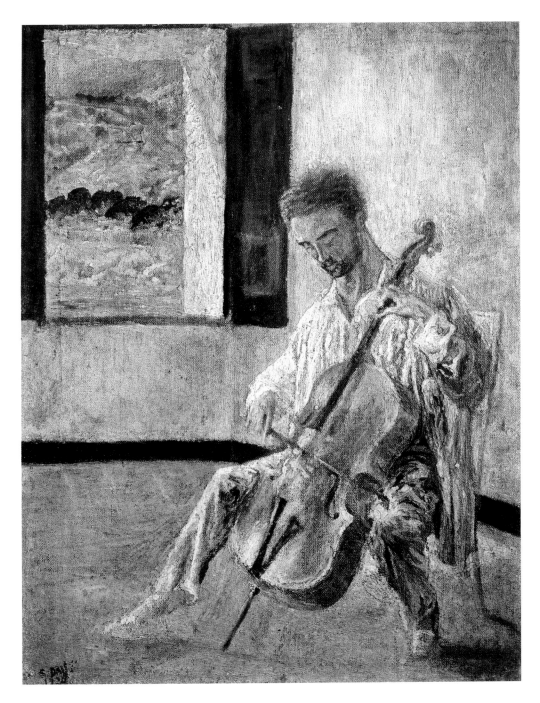

41

View of Cadaqués from the Creus Tower, c. 1923

Oil on canvas
98 × 100 cm
Fundació Gala-Salvador Dalí, Figueres

Cadaqués was the birthplace of the artist's father. It was, at that time, a small village located on the peninsula Cape Creus, where residents of Empordà (including the Dalís and Pichots) came to spend their summers. The Dalí family's summer house was on Es Llaner (Es Llané) beach, adjacent to Cadaqués. The region has been inhabited since prehistoric times and was settled by Greeks and Phoenicians. It was a trading post in the Roman Empire, with *amphorae* from sunken Roman ships being occasionally recovered on the beach to this day. Inhabitants of Cadaqués and neighbouring villages made their living from farming the terraced hillsides, fishing and smuggling; with domestic tourism providing income from the late nineteenth century onwards. The Empordanese have been described as stubborn and idiosyncratic, made difficult by exposure to the strong wind of the region, called the *tramontana*.

Cadaqués, Portlligat and Cape Creus would be profoundly important for Dalí all his life. Art critic Brian Sewell, his companion for a short time in the 1960s, noted, "The beach always had an astonishing effect on him, as though he had never seen it before. I was at first dismayed by this Alzheimer effect, but I think now that he was invariably overwhelmed by so dense a rush of memories that he could not speak."

Landscape and sea views would appear in Dalí's first paintings (from the early 1910s) and would be imprinted on his imagination throughout his life. Young Dalí painted landscapes, sea views, boats and buildings in the local area; this view shows Dalí synthesising direct observation with geometric facets of Cubism. Dalí knew of Picasso's time in Cadaqués making Cubist art and, highly ambitious, would have seen himself in competition with his illustrious compatriot. The combination of practising oil painting at a young age, rigorous training in drawing, poring over illustrations of Old Master works and exposure to Modernist art in journals would make Dalí a formidably protean and technically adept artist.

Portrait of Luis Buñuel, 1924

Oil on canvas
70 × 60 cm
Museo Nacional Centro de Arte Reina Sofía, Madrid

Dalí encountered the future film director Luis Buñuel at the Residencia de Estudiantes, Madrid, while living there. Buñuel was a natural-history student from Aragon and the background of this painting seems to be an evocation of Aragon, a region the painter did not know. Buñuel's intelligence, fierce anti-authoritarianism and athletic prowess impressed Dalí. They became good friends and collaborated on two films before parting ways. Relations between Buñuel and Dalí became strained over the 1930s. Buñuel disapproved of Dalí's support for Franco; Dalí was angry that the director had edited him out of the screenplay credits for L'Age d'or and had discounted the painter's involvement in that movie. When in need of a loan in 1939, Buñuel (aware that Dalí was, by now, rich) was offended when Dalí refused his written request for money. They never met again.

Buñuel was a scourge of established values. His films criticised the Church, monarchy, capitalism, colonialism, traditional families, bourgeois sexual morals and conventional sentimentality. Surrealist touches recur in Buñuel's films. In many respects, both director and painter were anti-establishment and non-conformist. Dalí could not be described as a "good Catholic" nor a conventional supporter of Franco—not least because of his pride in Catalonia, which was an anti-Falangist position—despite seeming to back the post-war status quo. Conventional socialists resented the intrusion of Surrealist imagery into Buñuel's social critiques.

After years of silence, the elderly Dalí reached out to Buñuel, a few months after Gala died. In an effort to revive his dwindling creativity, he sent Buñuel a telegram, with an idea for a film collaboration. Buñuel replied "I RECEIVED YOUR TWO CABLES, GREAT IDEA FOR FILM [entitled] LITTLE DEMON BUT I WITHDREW FROM THE CINEMA FIVE YEARS AGO AND NEVER GO OUT NOW. A PITY. EMBRACES." Buñuel died eight months later, in Mexico City.

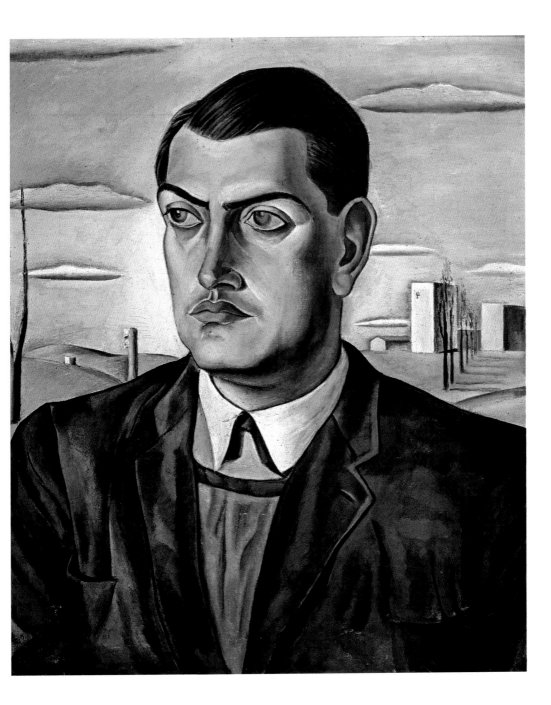

45

Pierrot Playing the Guitar (Cubist Painting), 1925

Oil on canvas
198 × 149 cm
Museo Nacional Centro de Arte Reina Sofía, Madrid

In the 1920s, Purism and Neue Sachlichkeit (New Objectivity) both lauded the creation of Modernist art that would reflect the modern world and present it with unflinching clarity and perfection. Much of the painting that was being taught and produced by the Bauhaus in this period was in these styles. Painter Amedée Ozenfant (1886–1966) and architect-painter Charles-Édouard Jeanneret (called Le Corbusier) (1887–1965) published *La Peinture moderne* in 1925, which explained the principles of Purism as adherence to modern styles, modern subjects and modern attitude. At the Residencia, Dalí was kept up to date on the latest art news from Paris. In 1926 he made his first visit to the French capital and visited the studio of Picasso, where he was greatly impressed by recent paintings combining figures, statues and still-lifes. *Pierrot Playing the Guitar (Cubist Painting)* is indebted to Cubism and is equally reflective of Metaphysical art and paintings by Futurist-turned-Neo-classicist Gino Severini.

In a 1927 letter to Lorca, Dalí wrote of his fanatical support for the new machine aesthetic. "No previous era has ever known such perfection as ours. Until the invention of the machine there were no perfect things, and mankind had never seen anything so *beautiful* or *poetic* as a nickel-plated engine. The machine has changed everything. Our epoch, compared to others, is MORE different than the Greece of the Parthenon from Gothic. You've only got to think of the badly made and highly ugly objects produced before mechanization. We are surrounded by a new perfect beauty, productive of new poetic states."

A photograph of the artist working on the painting (in the presence of his uncle Anselm Domènech) suggests it was made in Cadaqués.

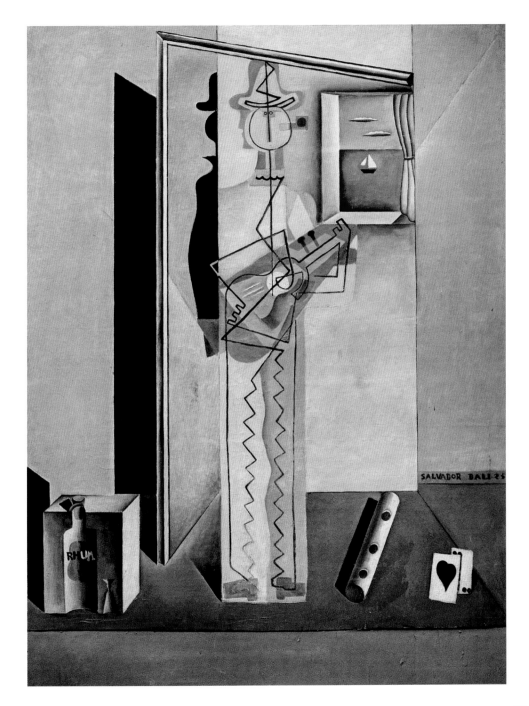

Cliffs, 1926

Oil on wooden panel
27 × 41 cm
Private collection

The igneous mica schist rock of Cape Creus is notable for its reddish-golden glow in sunlight and for the intricate shapes it forms when eroded. The strange formations can—when viewed with an open imagination—resemble objects, animals or people. Lorca, Buñuel and other visitors were captivated by the effect and Buñuel was enthusiastic about filming the climax of *L'Age d'or* there for this reason.
Here we get a more conventional treatment of the local geology. An inscription on the rear of the panel identifies the location as Cabo Norfeu (Cabo Norfeo). This location is within walking distance of Cadaqués. In the period 1925–27, Dalí was alternating between classicism and his machine aesthetic. Female bathers allow the libidinal artist to dwell on nudity. Dalí has emphasised the diagonals that divide the picture almost perfectly into quarters, with one diagonal following the line of shadow, the other the downward sloping slant in the rocks that is accentuated at the top left by the edge of the clouds. This bold X composition can also be found in *Family of Marsupial Centaurs* (1940). Female bathers were a common subject for the artist at the period, influenced by Picasso's Neo-Classical style, with Anna Maria sometimes taken as a starting point for largely imagined compositions.
This painting was originally owned by the painter's uncle, Anselm Domènech, who lived in Barcelona. Anselm bought the painting from his nephew's solo exhibition at Galeries Dalmau, Barcelona. He was especially supportive of the young Dalí and tried to mend the break between the painter and his family. Dalí's appreciative letters to him are a useful source of information about the artist's early years.

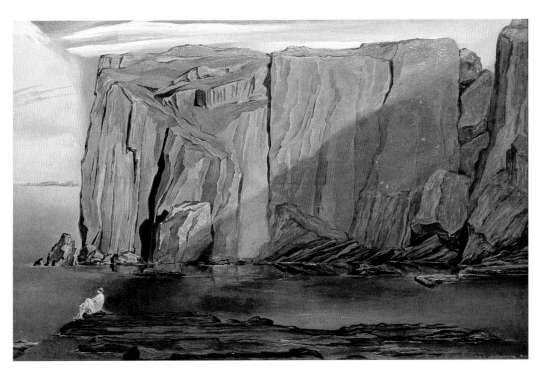

Apparatus and Hand, 1927

Oil on wooden panel
62.2 × 47.6 cm
The Dalí Museum, St. Petersburg (Florida)

Painted in summer 1927, *Apparatus and Hand* shows a hardening of forms and firmer description of pictorial space than the preceding paintings. This comes following Dalí seeing Tanguy's paintings at the Galerie Surréaliste, in Paris in April 1926 and from seeing illustrations in *La Révolution surréaliste*.

This Lorca-period painting has been interpreted as an allegorical symbolisation of Dalí's (self-confessed) addiction to masturbation. The red hand is the hand of the masturbator and the triangular form below symbolises female genitals, with the grooved object below also being a vagina. His biographer Gibson wrote of this painting, "Among his other achievements, Dalí was the first serious artist in history ever to make onanism one of the principal themes of his work."

A missing masterpiece from the Lorca period is the canvas *Blood is Sweeter than Honey* (1927), which once belonged to Coco Chanel but has since disappeared. The Dalís were friendly with Chanel, Elsa Schiaparelli and Christian Dior in the 1930s and 1940s.

Apparatus and Hand was acquired by Albert Reynolds Morse (1914–2000) and Eleanor Morse (1912–2010). The couple started collecting Dalí in 1943 and built up the most comprehensive collection of Dalí's art in world—in terms of quality, even exceeding the artist's own collection. They also formed a personal friendship with the artist and his wife, keeping a diary of the artist's activities and statements which scholars have used as a historical record. Reynolds Morse also acted a trusted advisor in the 1970s and 1980s, when the artist faced financial, legal and health problems. Initially located in Cleveland, Ohio, the Morses' collection (containing 2,400 works of art by Dalí) is now housed at the Dalí Museum, St. Petersburg, Florida.

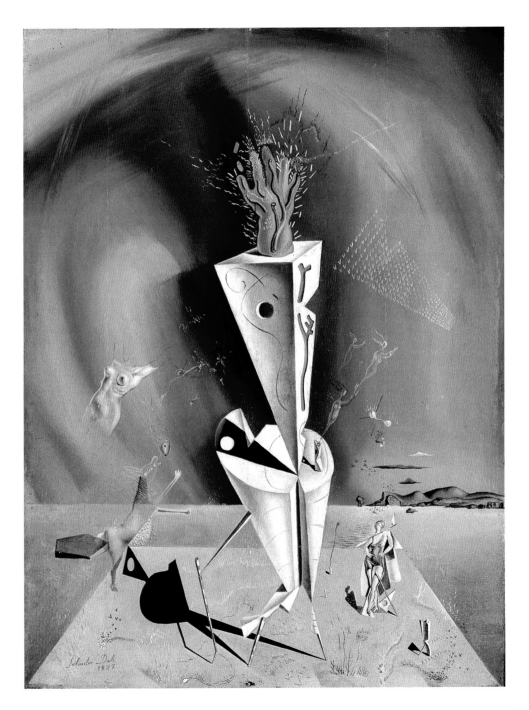

Bird, c. 1928

Oil, sand, pebbles and shingle on board
49.7 × 61 cm
Scottish National Gallery of Modern Art, Edinburgh

Dalí incorporated sculptural, non-art elements into his paintings in the late 1920s. Ernst, Picasso and André Masson incorporated sand, sawdust and other ordinary granular material into paintings, as a way of adding texture and variety. It also broke conventions by adding objects from the real world into a painted one.

Dalí was fascinated by death and decay and described biting a rotting bat. In the Residencia, "putrid" was used as an insult. Dalí went one step further by incorporating ideas of putrefaction into his aesthetics and making it a subject for art. Still-life painters had for centuries been alluding to decay and the transitoriness of earthly existence. Dalí went considerably further, giving free rein to his obsessive attraction-repulsion complex regarding putridity.

Miró's flat semi-abstract art had achieved acclaim in Paris by the time of Dalí's first visit there in 1926. The earthy primal quality of Miró's subjects and the radical innovation of his style seemed to lay open the potential of conquest of Paris by Dalí, an equally ambitious iconoclastic Catalan painter. Miró's subjects often included animals he was familiar with from his homeland. He had also begun his career with a solo exhibition at Galeries Dalmau, Barcelona and the older artist had been instrumental in introducing the young Dalí to important dealers, collectors and fellow artists. *Bird* is Dalí's homage to his Surrealist colleagues, including elements from his own experience of exploring the beaches on Cape Creus.

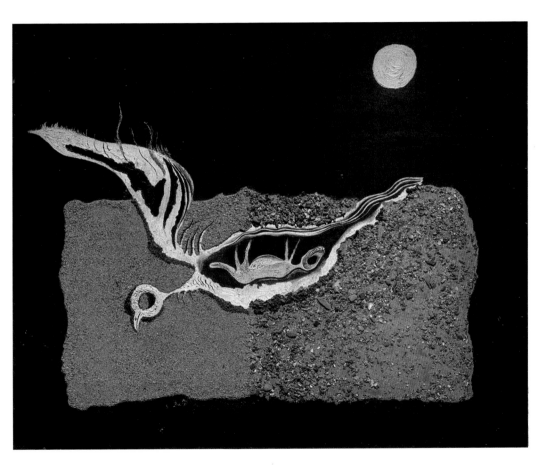

Portrait of Paul Éluard, 1929

Oil on cardboard
33 × 25 cm
Private collection

This portrait was begun from life in August 1929, while the poet was staying at Cadaqués, at a time when his wife and Dalí had begun their affair. The painting was completed the following month. A Chinese lion of desire confronts the (feminine) face jug, while the poet is adorned by a sleeping figure-fish amalgam, an ant-covered host wafer, a giant grasshopper and hands. Hands stifle a moth, touch the grasshopper and clasp one another. A landscape, head and Art Deco arabesques emerge from Éluard's lapel. Tiny figures in the landscape below are shown struggling (top right), a boy accompanied by his father (left) and two men pursuing geometrical shapes (symbolising unattainable prizes, probably the female genitals) at the far-right side. The white form with animated rods had appeared in Dalí's paintings since 1926.

Éluard was born Eugène Émile Paul Grindel in 1895. After military service during World War I, he and Gala lived in Paris, partly funded by dealing art. Éluard would become a key figure in the Surrealist movement, with only Breton more prominent. Generous, sensitive and a brilliant poet, Éluard was beloved by colleagues, whereas Breton was more revered and feared. Éluard's 1942 poem "Liberty" was taken up as an emblem of hope and resistance in occupied France, which turned him into a figure of international repute. The admiration in which he was held was evident in the spontaneous mourning by crowds at his funeral, following his death on 18 November 1952.

This portrait was first exhibited at Galerie Goemans, Paris from 20 November to 5 December 1929. It later belonged to Cécile, daughter of Éluard and Gala.

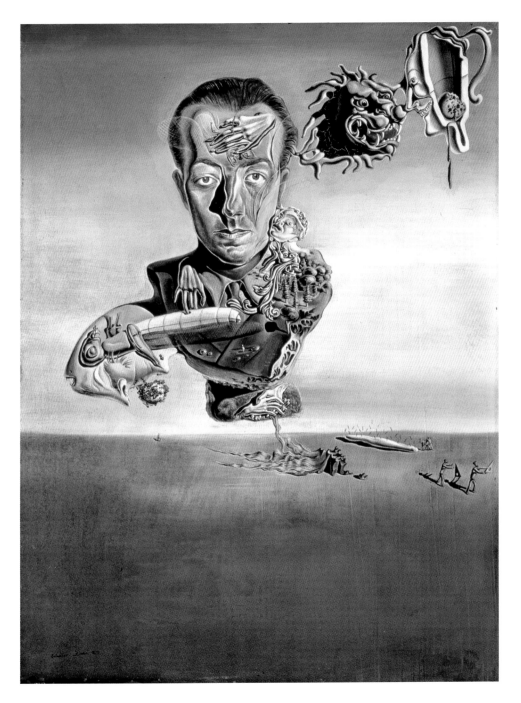

Enigma of Desire *or* My Mother, My Mother, My Mother, 1929

Oil on canvas
110.5 × 150.5 cm
Bayerische Staatsgemäldesammlungen, Sammlung Moderne Kunst,
Pinakothek der Moderne, Munich

The sleeping personage here is a composite. The head (which appears feminine but has been interpreted as Dalí himself) comes from a weathered coastal rock; the body is reminiscent of rounded relief sculptures by Arp and smooth leaden plaques in paintings by Magritte. In recesses is inscribed "Ma mère" (my mother). Dalí's mother is notably absent from Dalí's father-dominated art. Art Nouveau (dismissed by Modernists) was full of delirious organic forms, according to Dalí, hence the inclusion of an ornamental scroll. Dalí wrote of his amazement encountering the Art Nouveau entrances of the Paris Métro. He had a phobia of ants, which appear swarming on the palm of a hand in *Un Chien andalou*. The cluster of entities on the left (incorporating weapons and symbols of desire (lion) and femininity (fish)) represents dangerous passions.

When *Enigma of Desire* was first exhibited (at Galerie Goemans, Paris), Breton wrote in the catalogue: "With Dalí it is perhaps the first time that our mental windows have opened completely and that we are going to feel ourselves slipping upwards towards the trapdoor to fulvous sky. [...] Dalí's art, the most hallucinatory that has been produced up to now, constitutes a veritable threat. Absolutely new creatures, visibly mal-intentioned, are suddenly on the move." Breton understood how revolutionary Dalí's contribution was to the Surrealist movement and the revitalising effect of his arrival. The Goemans exhibition (including *Apparatus and Hand* and *Portrait of Paul Éluard*) established Dalí. All eleven paintings sold, although prices were not high. Young aristocratic supporters bought art and dined the glamorous Dalís. The Comte and Comtesse de Noailles paid Dalí enough money for him to buy a fisherman's cottage at Portlligat in March 1930.

At this time, Magritte was also painting female torsos in compartments or recesses. Magritte and Dalí both shared Goemans as their dealer in 1929 and 1930. The pair were on friendly terms but (following Magritte's departure for Brussels in 1930 and Dalí's rise to fame) the relationship became cooler. Proper assessment of their early relationship is impossible; Magritte burned letters that he received from the Surrealists.

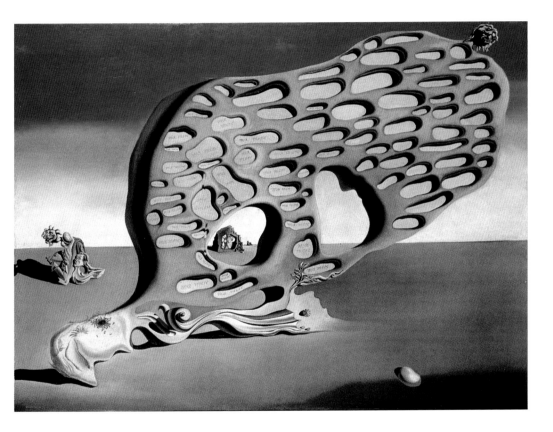

Imperial Monument to the Woman-Child, 1929

Oil and collage on canvas
140 × 81 cm
Museo Nacional Centro de Arte Reina Sofía, Madrid

The concept of woman-child—named in the title of this painting—was developed by Breton. The Surrealists' ideal muse was the *femme-enfant* (woman-child), who had a child's innocence, curiosity and lack of intellect and the passion and sexual libido of an adult. It allowed Surrealists—who valued imaginative freedom above all—to blur the distinctions between children and women. Art by Hans Bellmer (1902–1975) and Balthus (1908–2002) raise uncomfortable questions about sexual imagery of children. The Surrealists (including Dalí, especially in his adolescent fantasies described in *Secret Life*) followed the Freudian line that children do have sublimated libidinal desires that only later become manifestly sexual.

Imperial Monument to the Woman-Child seems to be the companion painting to *The Invisible Man* (1929–33). They are of the same dimensions and were both started around the same time, although biographer Ian Gibson thinks that this painting was mainly painted in 1930 in Paris. The pair act as compilations of separate motifs that fascinated Dalí and reappear elsewhere. The kneeling skeletal figure would be the central subject of *Javanese Mannequin* (1934). The feminine being resting on its nose (wearing a crown) at the bottom left appeared in *The Enigma of Desire* (page 57) and other paintings. The car-fossil appears in paintings of 1936; keys in alcoves recur until the mid-1930s. This is the first appearance of the figures of *The Angelus*. Although Napoleon, the Mona Lisa and the fossilised bird do not come back, the roaring lion, woman-jug and staring faces can be found elsewhere in Dalí's paintings of the era. The hand with cigar is a phallic substitute. Some critics have interpreted the female back and buttocks as Gala's first appearance within Dalí's art.

An idol for Dalí was Catalan architect Antoni Gaudí (1852–1926), whose elongated organic forms—tattered and pierced, as seen in his Sagrada Família cathedral in Barcelona—resemble the weathered rocks of Cape Creus. It is claimed Gaudí once visited Cape Creus.

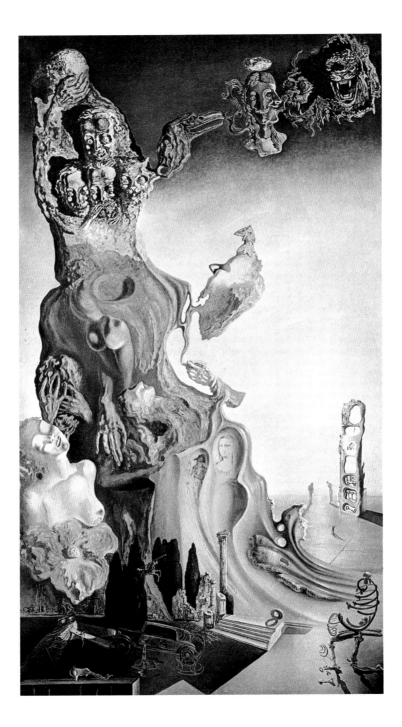

The Persistence of Memory, 1931

Oil on canvas
24.1 × 33 cm
The Museum of Modern Art, New York

In his autobiography, Dalí described the development of *The Persistence of Memory*. Gala, friends and the artist dined before leaving Dalí alone. "We topped off our meal with a very strong Camembert, and after everyone had gone I remained for a long time seated at the table meditating on the philosophic problems of the "super-soft" which the cheese presented to my mind. I got up and went into the studio, where I lit the light in order to cast a final glance, as was my habit, at the picture I was in the midst of painting. This picture represented a landscape near Port Lligat, whose rocks were lighted by a transparent and melancholy twilight; in the foreground an olive tree with its branches cut, and without leaves. I knew that the atmosphere which I had succeeded in creating with this landscape was to serve as a setting for some idea, for some surprising image, but I did not in the least know what it was going to be. I was about to turn out the light when instantaneously I "saw" the solution. I saw two soft watches, one of them hanging lamentably on the branch of the olive tree." When Gala saw the painting on her return, she declared, "No one can forget it once he has seen it." Peculiarly, Dalí described not three soft watches but two; perhaps that third was added later or Dalí's memory played a trick on him.

This is the most famous product of the paranoiac-critical method, which Dalí claimed allowed access to irrational knowledge. Losing inhibitions permitted a person's subconscious to emerge and allowed him to perceive connections not apparent to others—effectively, harnessing paranoia.

Gallerist Julien Levy bought the painting for $250 and took it to New York, where it made the artist's reputation. It was critiqued, mocked, adulated and discussed throughout the press, with its novelty and memorability taking America by storm. Already, widely reproduced and exhibited, it was included in Dalí's first solo exhibition at the Julien Levy Gallery in New York from 21 November to 8 December 1933.

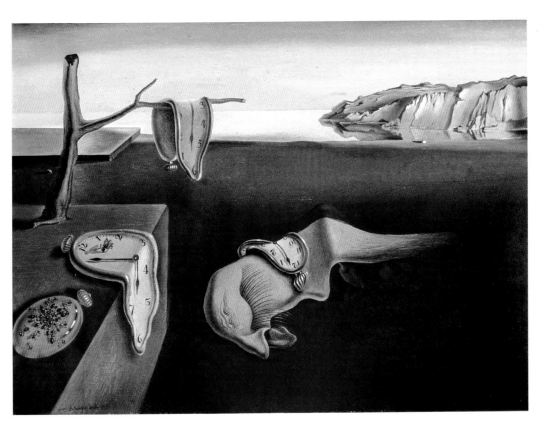

Birth of Liquid Desires, 1932

Oil and collage on canvas
96.1 × 112.3 cm
Peggy Guggenheim Collection, Venice

A young woman embraces a bearded hermaphrodite, who seems reluctant, and whose foot is being watered by a partly hidden figure. A man (nude apart from a single sock) is reaching into a pool of water, which has its own source. Another source of liquid in the scene is a flow emitted from a wardrobe, which irrigates two cypresses from Dalí's childhood, all of which is an extrusion from the head of the hermaphrodite, and which incorporates a phallic loaf.

Reading the painting in Freudian terms is not easy, despite the use of symbols of a yearning for the womb (the pool of water), desire (the woman and hermaphrodite), phalluses (cypresses, loaf), female sex (bowls, cavities) and ejaculation (flowing water). The artist did not always venture interpretations of every painting, although (as he did write of having intra-uterine memories) we can assume this was on his mind when he painted *Birth of Liquid Desires*. When Dalí had a short meeting with Freud in London on 19 July 1938, Freud was impressed by the painting Dalí brought with him (*The Metamorphosis of Narcissus*, 1937.) Whereas previously Freud had dismissed Surrealism, "this young Spaniard, with his ingenuous fanatical eyes, and his undoubtedly technically perfect mastership, has suggested to me a different estimate. In fact, it would be very interesting to explore analytically the growth of a picture like this."

A strong part of the appeal of this painting is the vivid contrast between the blue of the sky and yellow ochre of the biomorphic form and the velvety dark green of the extrusion. There is also something satisfying about the shapes and tactility of the rounded forms, despite the precarious slenderness of the spoon-like tong. The contrast of textures and materials depicted and the shapes and pungent colours make *Birth of Liquid Desires* one of Dalí's most pleasing paintings.

Gala sold this painting (which was apparently started in 1931) in the autumn of 1939 to millionairess art collector Peggy Guggenheim, who was buying art from artists desperate to turn fragile bulky paintings into cash, as they fled the impending war.

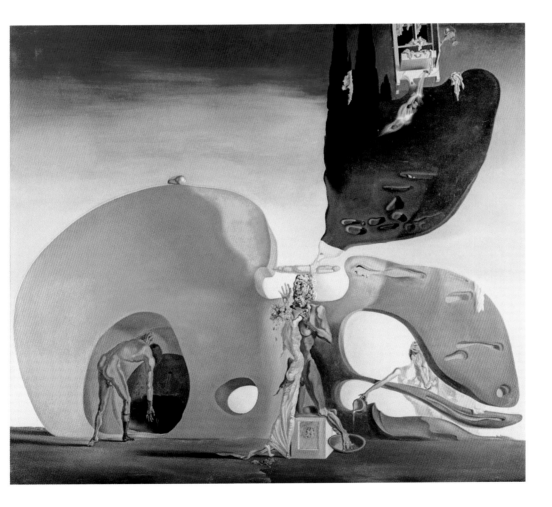

The Real Painting of *The Isle of the Dead* by Arnold Böcklin at the Hour of the Angelus, 1932

Oil on canvas
77.5 × 64.5 cm
Von der Heydt-Museum, Wuppertal

Arnold Böcklin (1827–1901) was a Swiss Symbolist painter who became famous in the late Victorian era for his painting *The Isle of the Dead* (first version 1880). It was widely reproduced and became an emblem of mourning, exuding a powerful uncanny morbidity. Dr Eduard von der Heydt, the first owner of this painting, was a prominent banker and politician in Nazi Germany. Dalí believed that this painting was shown to Hitler and made a great impression on him. The painter associated Hitler with the *The Isle of the Dead* and in this instance he was correct. What Dalí did not know was that at this time Hitler was also fascinated by the painting. In 1933, Hitler purchased one of Böcklin's five painted versions of the composition to hang in his Berghof holiday residence. That version is currently owned by the Alte Nationalgalerie, Berlin. For a discussion of *Angelus*, see page 72.

The power of Dalí's Surrealism in large part comes from the portrayal of objects dwarfed by open landscapes and seascapes. Large areas of open space and small motifs can be seen in Tanguy's paintings, which Dalí admitted he hugely admired. In many of Dalí's best loved paintings almost nothing is happening. Merely existing in this strange yet familiar private imaginative landscape is one of greatest pleasures in art and (among the Surrealists and Metaphysical painters) can similarly be experienced when viewing the paintings of de Chirico, Magritte, Tanguy and Dalí. Dalí painted a later variation on this painting, entitled *Flying Giant Demi-Tasse with Incomprehensible Appendage Five Metres Long* (c. 1944), which lacks the sombre palette of the original.

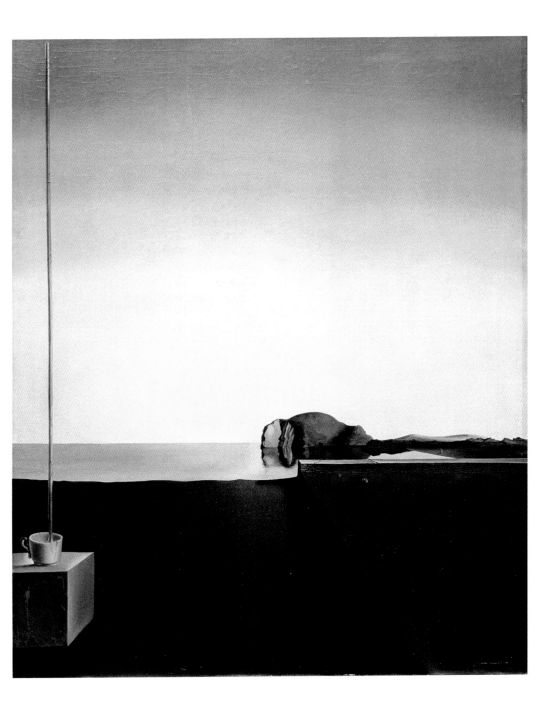

The Enigma of William Tell, c. 1933

Oil on canvas
201.3 × 346.5 cm
Moderna Museet, Stockholm

Dalí's interpretation of this painting is that Lenin is fused with his father and that Lenin is holding the young Dalí with a chop on his head. The visor of Lenin's cap and one distended buttock (the latter forming a giant phallus) are supported by crutches. By his foot is a nutshell crib that cradles the infant Gala, in danger of being crushed. The preparatory drawing has this tableaux in a landscape. The sense of claustrophobia and menace is enhanced by the removal of that landscape. William Tell was the tale of a father who was forced to prove his sharp-shooting abilities by bringing down an apple from the head of his son. In Dalí's imagination, his father's competence, virility and hostility was a threat to him, creating an emotional complex that would dominate his personal relationships (see page 25 for further discussion on this).

On 23 January 1934 Breton asked Dalí to explain his aberrant positions. He had disparaged Modernism, shown too much fascination with Hitler (a known opponent of Communism) and had displayed an anti-egalitarian attitude. Breton was also concerned by the painting *The Enigma of William Tell*, which was disrespectful towards Lenin. Dalí replied that he was following Surrealist doctrine by expressing subconscious desires, however strange, and that his duty as a Surrealist was to set aside morality in order to explore his obsessions.

When this painting was first exhibited (on 2 February 1934), Dalí was expelled from the Surrealist movement for "counter-revolutionary acts tending to the glorification of Hitlerian Fascism". Breton led the Surrealists to the exhibition, intending to destroy the canvas, but found it was positioned too high for their sticks to reach. The expulsion was later rescinded, after Dalí signed a document declaring himself to be an ally of the proletariat. The final break came in 1939 (page 88).

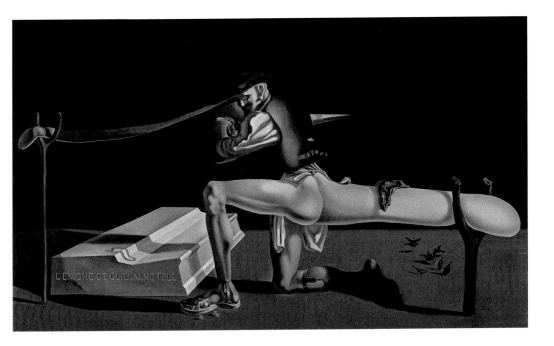

Atavistic Vestiges after the Rains, c. 1934

Oil on canvas
65 × 54 cm
Private collection

In one of Dalí's most serene and haunting landscapes, a father and son gaze
in wonder at a giant white biomorphic-geological form that has risen over the
plain of Empordà after the rains. Contrary to Dalí's depictions, the region is lush
rather than arid, although subject to the strong *tramontana*. It is rich and verdant
farming land. Dalí removed the foliage to make his scenes starker and more
imposing, although there are some paintings that included indications (rather
than descriptions) of vegetation. This setting—the plain with a large form viewed
by spectators—recurs often in this period and is the basis for two other enduring
images: *Millet's Architectonic 'Angelus'* (1933) and *Archaeological Reminiscence
of the 'Angelus' by Millet* (c. 1934). The former painting has two white biomorphs
that imitate the figures of the *Angelus*, one with an exaggerated phallic extension.
The cypresses of Böcklin reminded him of the two cypresses he saw from his
schoolroom. "The two cypresses outside, which during the whole afternoon
seemed to be consumed and to burn in the sky like two dark flames were for me
the infallible clock by which I became in a sense aware of the monotonous rhythm
of the events of the class."
Dalí's complex relationship with his father (as discussed regarding the previous
painting) takes a more benign turn here. Rather than seeking to devour or expel
the boy, this father presents to him the mysterious wonders of the world, giving
the pair an opportunity to bond and share.
The solid form with a rounded hole can be found in many other paintings and
sculptures. A cast polished metal statue of this painting's biomorphic form
(complete with supporting crutch and onlookers) was editioned in 1969. This
painting once belonged to the Italian film producer Carlo Ponti and is now in a
private collection.

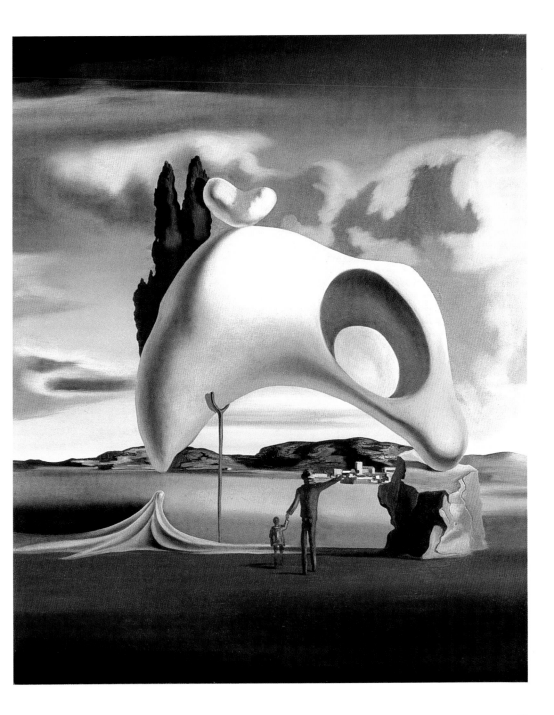

Enigmatic Elements in a Landscape, 1934

Oil on wood panel
72.8 × 59.5 cm
Fundació Gala-Salvador Dalí, Figueres

Johannes Vermeer (1632–1675) was part of Dalí's pantheon of heroes ever since he encountered art as a boy. Here Vermeer, as adapted from his *Allegory of Painting* (c. 1666–68) is set on the plain of Empordà, between two walls. He is painting the bell tower of the Church of Santa Maria in Cadaqués, an imaginary tower (inspired by Molí de la Torre), cypresses and a giant form wrapped in a sheet. Figures and objects draped in sheets were a persistent motif at this time. For the artist, they indicated symbols or acts too unthinkable to be contemplated, which the person was unwilling (or unable) to confront directly. In the distance are two white biomorphs (yin-yang beans) embracing, watched by the boy Dalí in a sailor suit and his seated nurse.

It is worth comparing *Enigmatic Elements in a Landscape* to another painting which is similar to the left side of the centre of this painting. That is *West Side of the Isle of the Death (Reconstructed Compulsive Image After Böcklin)* from 1934, in which we find the trees from Böcklin's painting and an imaginary tower juxtaposed beside a sheet-covered form.

The clouds here are on the verge of presenting recognisable forms, as they do in some paintings of this time. Dalí is toying with our tendency to see figures, animals and faces in natural abstract phenomena. This trait in humans is called pareidolia and has been subject to much psychological research in recent decades. Dalí's impressionable imagination was continually transforming natural objects into other things. This was, in fact, the very basis for his paranoiac-critical method, which was in fact never a method but a combination of imagination and pareidolia.

The Angelus of Gala, 1935

Oil on wood panel
32.4 × 26.7 cm
The Museum of Modern Art, New York

From 1929 onwards, Gala became the most constant presence in Dalí's art. This portrayal shows Gala at perhaps her least glamorous. The painting acts as a homage to Dutch and Spanish Golden Age painting, which Dalí absorbed through the Gowans Art Books series on the Old Masters and later at the Prado, while studying at the academy.

The Angelus (1857–59) was a painting by Jean-François Millet (1814–1875), showing a scene of peasants praying in a field at twilight, standing next to a wheelbarrow. It became very famous as a depiction of humble piety and rural simplicity. One of many lithographic reproductions of the picture hung in Dalí's schoolroom. Upon retrospection and in the light of Freud's psychoanalytic theory, Dalí saw his obsession with the picture as psycho-sexual in nature. The man holding his hat was not a sign of reverence but concealment of his erect phallus as he is aroused by the woman, who is his mother; the wheelbarrow and pitchfork in the ground are symbols of copulation. Thus, Dalí's emotional complexes and libidinal drive transformed a paean to piety into an embodiment of sexual obsession.

In The Angelus of Gala the artist has placed his muse facing herself, with one Gala on a box or plinth and the other on a wheelbarrow. On the wall behind is a version of Millet's painting, considerably changed from its actual appearance. The calmness and hallucinatory detail both describe and evoke a dreamlike state. The inexplicable doubling is also oneiric (dreamlike) in quality. Uwe Schneede notices the folds in the back of the foremost Gala resemble a caressing hand.

Three Young Surrealist Women Holding in their Arms the Skins of an Orchestra, 1936

Oil on canvas
53 × 65 cm
The Dalí Museum, St. Petersburg (Florida)

Of softness, the artist said, "The best moment of time is the moment of time becoming soft and melting the same as divine Camembert cheese." The closest of ripeness to putrefaction was delightful to Dalí, who forever dwelt on the mingling of pleasure and repulsion. The softness of artefacts and entities represents transition and dissolution, exquisite because it is unstable. Dalí enjoyed music, including the operas of Wagner and the traditional Catalan folk dancing songs called sardana.

The cliffs here look similar to the chalk cliffs of Kent in England. Dalí first visited England in 1934 to attend an exhibition of his art. He would later stay with Edward James (1907–1984), leading English patron of Surrealism. In 1935 James and Dalí had met in Catalonia; the following summer the Dalís stayed at James's house in London. The artist signed a contract selling James his yearly output in return for a generous stipend, an arrangement running from June 1937 to June 1938. The security of this contract allowed Dalí time to craft his paintings to perfection, without financial concerns.

The International Surrealist Exhibition in London ran from 11 June to 4 July 1936 and proved to be a huge success. When it opened there were so many visitors that the street outside the Burlington Galleries had to be closed by police. Dalí delivered a lecture there, dressed in a diving suit and accompanied by two borzoi dogs. He began to suffocate and had to rescued. He later explained that he was demonstrating the need to immerse oneself in the subconscious.

During the exhibition, Sheila Legge (1911–1949) brought to life Three Young Surrealist Women Holding in their Arms the Skins of an Orchestra. She stood in Trafalgar Square, wearing gloves and a long dress, with her head covered by a sphere of roses. Surrounded by pigeons and situated before the façade of the National Gallery, photographs of her bear witness to a participatory appetite for Surrealism in London during the summer of 1936.

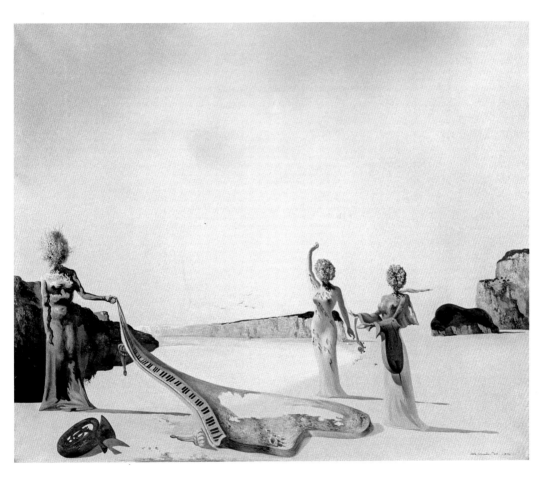

Soft Construction with Boiled Beans (Premonition of Civil War), 1936

Oil on canvas
99.9 × 100 cm
Philadelphia Museum of Art, Philadelphia
The Louise and Walter Arensberg collection

This painting was started in early 1936, the subtitle was added after the civil war had commenced. Dalí wrote of World War II, "War had transformed men into savages. Their sensibility had become degraded. One could see only things that were terribly enlarged and unbalanced. After a long diet of nitro-glycerine, everything that did not explode went unperceived." In this gargantuan monstrosity, we experience the savagery Dalí detected in war. It is a painting that could hang beside Goya's *Disasters of War* (1810–1820).

Monstrous semi-personages struggle in a richly described Empordaen landscape under a cloudy sky. Like other paintings, it includes some of the painter's favourite food. It is fittingly monumental in character. Monumentalism (achieved through low viewpoint, reduction in colour and simplification of form) emphasises the mass of bodies. In some respects, these bodies are variations on the grotesque beings copulating and fighting that the artist had drawn for the *Les Chants de Maldoror* illustrations. On the left is a figure the artist described in the title of another 1936 painting: *The Chemist of the Empordà in Search of the Void* (1936).

Dalí supported the Nationalist side in the Spanish Civil War, which lasted from 1936 to 1939. He differed from the Surrealists, writing that he saw war not as a political but as a natural struggle, a primal phenomenon. The ferocity of the conflict was traumatic for the Spanish nation. Every Surrealist who spoke publicly—with the exception of Dalí—supported the Spanish Republicans. The Surrealists not only supported the anti-clericalism of the Spanish Republican government, but they also had demanded a full Marxist revolution. "[…] burning chapels were to revenge the bonfires of human flesh previously set alight by the Spanish clergy; the church treasures should be seized to finance the weapons necessary for transforming the 'bourgeois Revolution' into a proletarian one." Christianity "must be exterminated".

Despite Dalí's strained relationship with Anna Maria, he was appalled that his sister was imprisoned and tortured by the Republican-controlled Military Intelligence Service during the Civil War. Dalí's supportive statements regarding Franco in 1939 were the final straw, and Breton expelled him from the Surrealists, permanently this time.

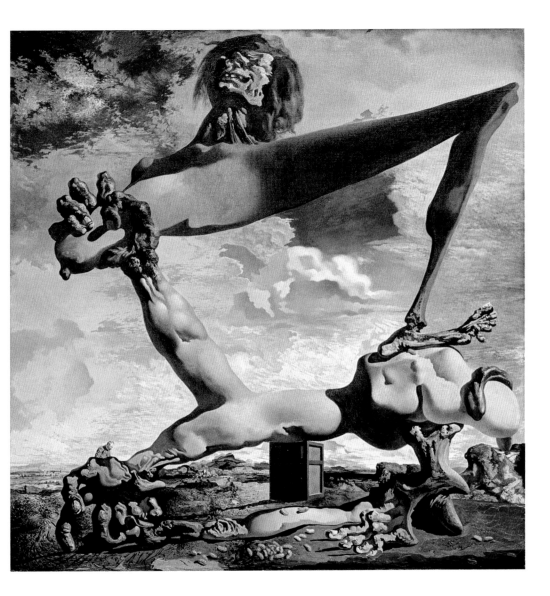

Autumnal Cannibalism, c. 1936

Oil on canvas
65.1 × 65.1 cm
Tate Modern, London

Another part of Edward James's fabulous collection, acquired directly from the artist, *Autumnal Cannibalism* presents us with a startling vision. Dalí draws an analogy between love and hatred, interdependence and resentment. According to the artist, "In the foreground of this landscape, the figures devour one another, swallow each other in order to become totally and completely identified with the loved one." The couple here are so intensely involved that they are oblivious to their situation and devour each other. They become fused in an ecstasy of carnal consumption, which does not preclude the possibility of hostility. As Dalí commented, "These Iberian creatures, devouring each other in autumn, symbolise the pathos of civil war seen as a phenomenon of natural history." Painted as the Spanish Civil War turned neighbours, colleagues and family members against one another in a fratricidal orgy—with atrocities committed by both sides—*Autumnal Cannibalism* shows us how close acquaintances can turn on one another while being locked in an embrace.

The table on which they rest is as expansive as a plain and their heads echo the distant headland. They are one with the landscape. There are many pictures by Dalí which dwell on the topic of cannibalisation and consumption of non-edible substances, such as furniture or shoes. For Dalí, such consumption is not only metaphorical of subconscious desire to possess something or achieve sexual gratification, but it is also literally the drive to eat. Dalí is one of the great painters of food in the modern era. Although Dalí did not paint still-lifes as a major part of his mature oeuvre, his Spanish sensibility and respect for Francisco de Zurbarán, Juan Sánchez Cotán and Juan de Valdés Leal meant that he was alive to the possibility of making art about food.

It is worth noting that British painter Glenn Brown (b. 1966)—perhaps the living artist closest to Dalí's meticulous technique and consummate academic finish—chose to pay tribute to Dalí in 1999 in a distorted and subtly altered transcription of this painting, entitled *Oscillate Wildly (After 'Autumnal Cannibalism', 1936 by Salvador Dalí)*.

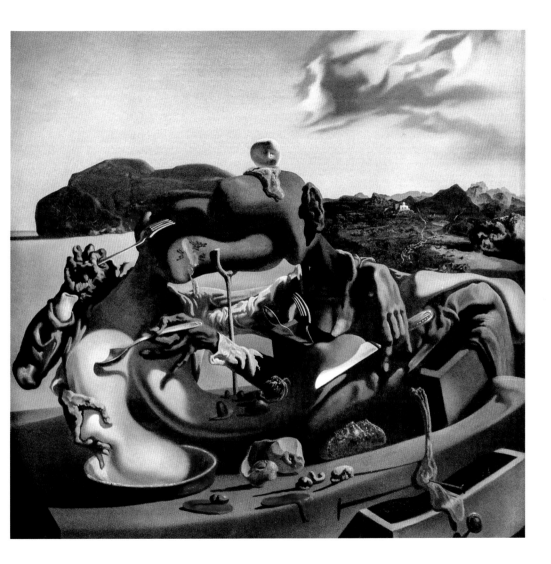

Lobster-Telephone, 1938

Telephone, plaster, paint
18 × 12.5 × 30.5 cm
Museum für Kommunikation, Frankfurt am Main

"I do not understand why, when I ask for a grilled lobster in a restaurant, I am never served a cooked telephone; I do not understand why champagne is always chilled and why on the other hand telephones, which are habitually so frightfully warm and disagreeably sticky to the touch, are not also put in silver buckets with crushed ice around them."

Dalí arranged the fabrication of four functional versions of *Lobster-Telephone*; the subsequent use of these as telephones caused the wear to the handsets. They were installed at the London home of Edward James (see page 74 for discussion of James). There are versions of *Lobster-Telephone* in London, Rotterdam, Canberra and Frankfurt. An unpainted white version exists in the Dalí Museum in St Petersburg, Florida.

In 1931 Dalí wrote an article that described Surrealist objects and advised some principles on how to devise them. He was opposed to these objects having sculptural qualities; instead, to match the revolutionary aims of the Surrealist movement, objects should combine already existent elements. A sculpture of a lady's shoe with a glass of milk inside was a piece Dalí exhibited in 1931. Communists were outraged, stating that milk was not suitable for sculpture and should instead be given to feed a child of the proletarian class. The *Dream of Venus* (1939) was a giant installation in in New York, within which Dalí posed some nude female models wearing lobsters.

Dalí (in collaboration with the fashion-conscious Gala) developed sculpture that was wearable, including *Aphrodisiac Jacket* (1936)—a dinner jacket covered by glass tumblers—and the famous shoe-hat, as made by Schiaparelli and modelled by Gala. Activity in this field was stimulated by Surrealist balls held in the 1930s and 1940s, where artists, high-society guests and celebrities vied with each other to wear the most outrageous and remarkable costumes. More scholarly attention has recently been paid to Dalí's collaborations in *haute couture*.

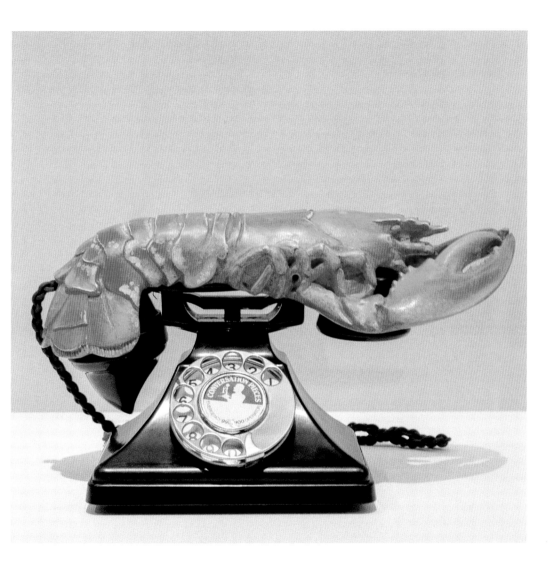

Spain, 1938

Oil on canvas
92 × 60 cm
Museum Boijmans van Beuningen, Rotterdam

Spain is a rather mannered and self-conscious evocation of the Civil War, which fails to match the power of *Soft Construction* and *Autumnal Cannibalism*. The title and technique indicate Dalí's ambition to work in the grand tradition. Use of dilute paint soaked into the support, scumbling (the light dragging of a brush, leaving a speckled effect) and loosely flickering brushstrokes give some oil paintings from 1936–1940 a distinctive appearance, close to wash-and-line drawings.

In *Spain* we see, ironically, the impact of Dalí's visits to Italy from 1935 onwards. The appearance of Leonardo-style cavaliers and heavily worked sketches of semi-nude figures, reflect a renewed acquaintance with Raphael and Leonardo, especially the unfinished panel painting *Adoration of the Magi* (c. 1478–82) and related sketches. There is a sombre Old Master palette of browns, blacks and earth hues (actually more typical of Rembrandt, whose paintings Dalí detested). The painterliness of Tintoretto and the drama of the architecture of Palladio can be seen in paintings such as *Palladio's Corridor of Thalia* (1937). This loose style disappears during the American period (1940–48) but would re-emerge at times in following decades.

Dalí claimed that Picasso viewed *Spain* in a 1939 exhibition and paid special attention to this painting. Picasso chose not to speak publicly about Dalí, which has been interpreted as a distaste or rejection of his art. Biographers state that Picasso was averse to responding to Dalí's constant yoking of the Spanish painters' names and achievements, especially after the younger painter declared support for Franco, whom Picasso hated.

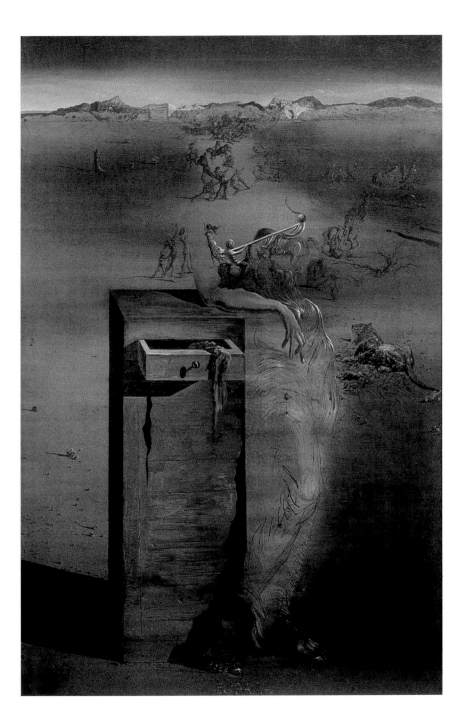

Imperial Violets, 1938

Oil on canvas
100 × 142.5 cm
Fundació Gala-Salvador Dalí, Figueres

Imperial Violets, another Edward James-owned masterpiece, is related to *The Sublime Moment*, *Melancholic Eccentricity* (also called *Mountain Lake*), both painted in 1938, and three 1939 works—*The Enigma of Hitler*, *Telephone in a Dish with Three Grilled Sardines*, *Landscape with Telephones in a Dish*—all paintings featuring telephones. These mark the end of Dalí's classic Surrealist period. He claimed that the telephones were inspired by diplomacy conducted partly by telephone during the Munich Crisis of September 1938, which narrowly averted war. As it turned out, war was postponed by a year. The severed cords indicate a failure to communicate.

The paintings of 1938–40 are some of Dalí's most beautiful and poignant. Application of paint in dilute washes, combined with warm earth hues and brooding shadowy settings, give these paintings a uniquely poetic quality. They are the sultry twilight before the night of war. They present Dalí using weather as an amplifier of emotion and exploiting atmosphere to brilliant effect. The climax comes in *Two Pieces of Bread Expressing the Sentiment of Love* (1940), which is saturated with warm golden-orange glazes, and was painted in Arcachon while Dalí was waiting to travel to New York. These paintings are the product of emotional maturity, painterly confidence and material stability. One wonders what might have been if the subsequent American period had not forestalled this development.

This canvas was acquired from the private market by the Fundació Gala-Salvador Dalí in 2015, effectively strengthening the Teatre-Museu Dalí's collection of oil paintings from his Surrealist period.

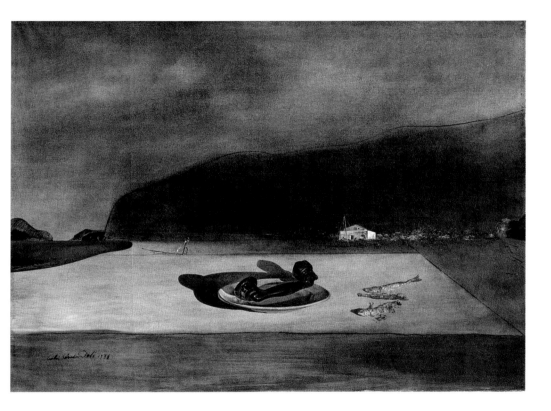

Soft Self-portrait with Grilled Bacon, 1941

Oil on canvas
61 × 51 cm
Fundació Gala-Salvador Dalí, Figueres

"The two luckiest things that can happen to a contemporary painter are: first to be Spanish, and second to be named Dalí. Both have happened to me." Such was the declaration of the artist in the catalogue for exhibition including this self-portrait. The inclusion of food is not just a humorous detail. Dalí often wrote and talked about food, demonstrating his visceral attachment of the simple sensory pleasures. Despite his sometimes intricate ideas and associations, Dalí's attachment to food generated some of his most famous imagery in *Autumnal Cannibalism*, *Lobster Telephone*, *Basket of Bread* and, of course, the Camembert cheese that inspired the soft watches of *The Persistence of Memory*.

Soft Self-portrait with Grilled Bacon could be seen as Dalí being subject to a Dalinian transformation and as a calling card for Dalí the public personality and the artist. Crutches hold up the malleable visage of the artist. The largest prop is damaged and in danger of collapsing, which indicates Dalí doubted his stability and feared mental collapse. The crutch was fixation since childhood. "Its aspect appeared to me at once as something extremely untoward and prodigiously striking", and he was seized with a "fetishistic fanaticism". It symbolised his fear of impotence.

This self-portrait is a type of self-promotion. Dalí took what seems now a very contemporary approach to his output, by treating happenings (such as Surrealists balls, window displays, lectures and photoshoots) as artistic events. He arranged dramatic events that would serve as publicity for new projects. These included charging through a giant copy of Vermeer's *Lacemaker* in a rhinoceros enclosure at a Paris zoo. There is a photograph of Dalí firing nails from blunderbuss at a lithographic plate in 1956, in the company of a concerned-looking Ernst. Dalí was photogenic and, when young, as handsome as a film actor. He posed for photographers such as Cecil Beaton, Philippe Halsman, Man Ray and others during the heyday of photojournalism. Having observed first-hand the power of the New York press and the Hollywood film industry, Dalí deployed zany and startling combinations of exhibition, performance, press launch and lecture to capture the public's imagination from the 1920s until his retreat from public life in 1983.

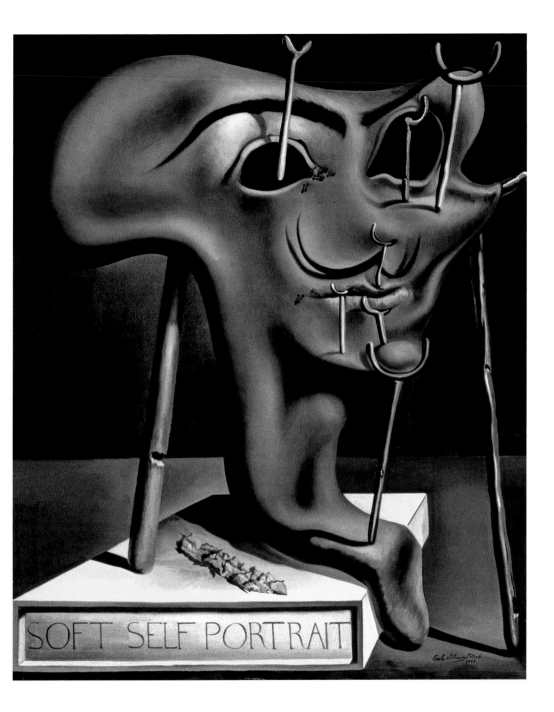

Poetry of America, 1943

Oil on canvas
116 × 79 cm
Fundació Gala-Salvador Dalí, Figueres

Although *Poetry of America* (also called *The Cosmic Athletes*) has been published as unfinished, it is signed. It deserves consideration as one of the more powerful and original of Dalí's America-era paintings, showing a genuine interaction with American society at multiple levels. Dalí claimed that the inclusion of the Coca-Cola bottle in this painting prefigured the rise of Pop Art over a decade later. The artist included figures playing baseball and American football in his paintings; although Dalí personally did not express any interest in sport, he noted it as a phenomenon.

Dalí stated that the vitality of the USA could be seen in its sports culture and that it partly stemmed from the athleticism of Black Americans. The sagging map of Africa on the tower, beneath a clock, indicates potential future conflict between the races. Breton claimed in 1939, from personal discussions with the artist, that according to Dalí "all the present trouble in the world is racial in origin, and that the best solution, agreed on by all the white races, is to reduce all the dark races to slavery." Breton then definitively expelled Dalí from the Surrealist group. While Dalí was undeniably both a contrarian and a reactionary in politics, it is difficult to tease out what the artist meant to be taken seriously, as a hypothecation or as a joke. This is what makes Dalí's statements both fascinating and frustrating for those wishing to pin him down on definite facts and beliefs.

The octagonal building is derived from that in Perugino's *The Marriage of the Virgin* (1503/4), a painting that also has a semi-circular top. The placement of a solid form pierced by space at the vanishing point of a picture was something Dalí would repeat in *The Madonna of Portlligat* (1949/50).

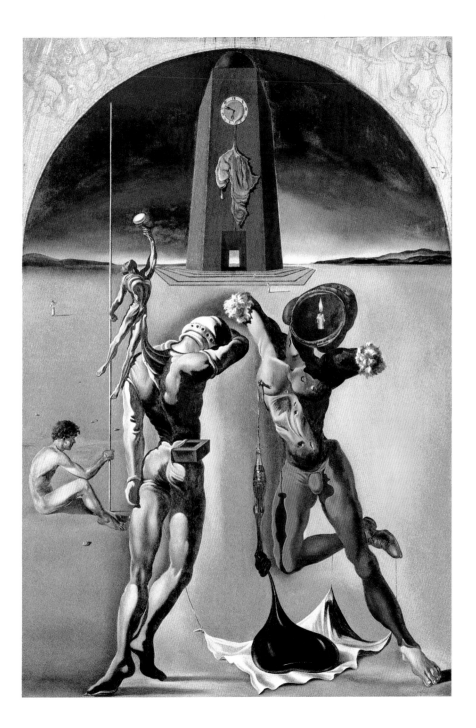

Dream Caused by the Flight of a Bee around a Pomegranate One Second before Waking, c. 1944

Oil on wooden panel
51 × 41 cm
Museo Nacional Thyssen-Bornemisza, Madrid

Perhaps Dalí's most dynamic composition, *Dream Caused by the Flight of a Bee around a Pomegranate One Second before Waking*, expresses the uninhibited eroticism and exhilarating fear of a dream. An arc of a fish, two tigers and a rifle with bayonet fly out from a pomegranate towards a woman. Whether the woman is the dreamer or the object of the dream is open to interpretation. Fishes appear in numerous still-lifes made since Dalí's student years and in some Surrealist paintings, including *Portrait of Paul Éluard* (page 55). In his nuclear-mystic period, the fish is a Christian symbol and included in paintings such as *The Madonna of Portlligat* (page 99). The arachnid-elephants carrying an obelisk—one of Dalí's most peculiar phantasms—were probably inspired by Bernini's sculpture in Rome of 1667, which was carved to support an ancient Egyptian obelisk.

Dream was to be followed by *The Apotheosis of Homer* (1944/5), which has a female nude figure in almost the same position as this one. That painting has a congested composition with numerous incidents and motifs filling the entire surface, overwhelming the viewer with detail. *Dream* gains strength by being simpler and more striking for its reduced motifs, which stand out strongly against predominantly cool and muted surroundings, and focus upon the stream of energetic and alarming entities on the point of penetrating the nude woman. The scene seems to be nearly exploding or disrupting, the way one wakes from dreams at a critical point.

Some have noted the clarity and brightness of the American period and have ascribed both to observation of the constant clear light of Monterey.

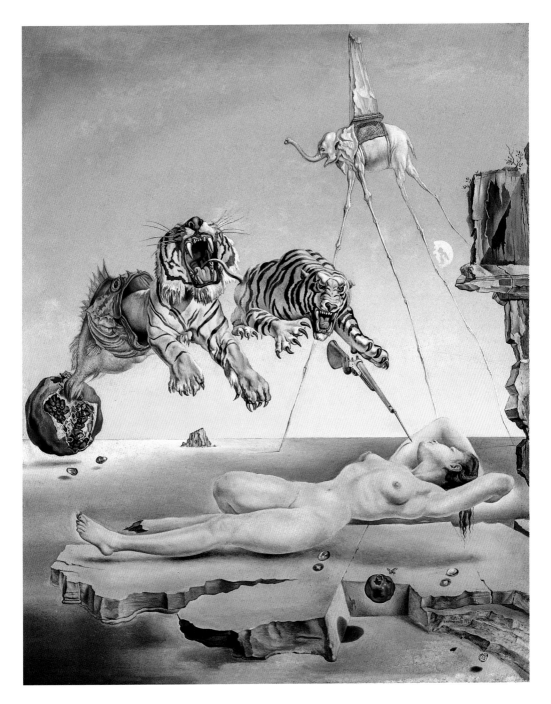

Portrait of Mrs Isabel Styler-Tas, 1945

Oil on canvas
65.5 × 86 cm
Staatliche Museen zu Berlin, Nationalgalerie, Berlin

This painting was executed while the Dalís were living in Monterey, California. Dalí was producing many portraits of celebrities and individuals associated with the Hollywood film industry. The standard format was the crisp and flattering portrait, set in a Dalinian landscape. This portrait—which displays more care and invention than most of Dalí's portraits of the 1940s and 1950s—is of Frau Isabel Styler-Tas, of Munich, who owned the portrait until 1958.

Dr Dieter Scholz of the Staatliche Museen zu Berlin provides background for this painting. "At the time of the portrait, 58-year-old Isabella Tas (1887–1971), daughter of the Jewish Amsterdam jeweler Louis Tas, had emigrated to Beverly Hills. [...] In 1957 Isabella Tas married the textile dealer Herbert Georg Stiehler in Munich, changing his name to Styler." The following year, Frau Styler-Tas sold the portrait.

Dr Scholz comments on the iconography. "A golden brooch shows the head of Medusa, whose evil gaze, according to Ovid, causes her counterpart to turn to stone. In addition, Dalí took up other pictorial traditions of art history. The austere juxtaposition recalls Piero della Francesca's portraits of the Duke of Urbino and his wife (c. 1465, Uffizi, Florence), the wooded rock recalls Giuseppe Arcimboldo's composite portraits, and the subtitle recalls Albrecht Dürer's copperplate engraving "Melencolia I" (1514). The erudite pictorial program was intended to flatter the sitter; at the same time, it can be seen that she was perceived as a tough personality who covered up her melancholy with a pompous appearance." The brooch was invented and clearly a reference to the profession of the subject's family.

Richard the Third (also called *Portrait of Laurence Olivier in the Role of Richard the Third*) from 1955 also displays what Dalí was capable of when he was truly engaged by portrait painting and is comparable to this painting of a non-public sitter.

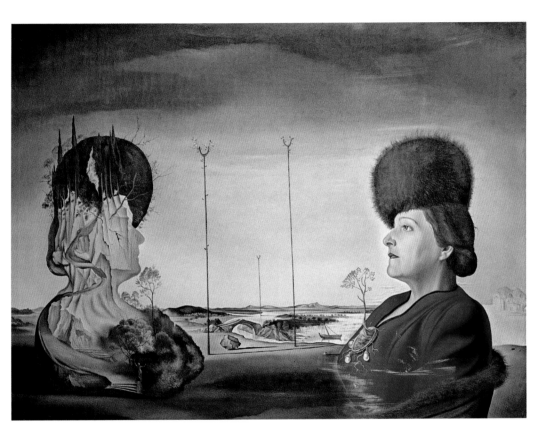

Basket of Bread, 1945

Oil on plywood panel
33 × 38 cm
Fundació Gala-Salvador Dalí, Figueres

This still-life shows Dalí's technique at its most impeccable. As a student in Madrid, Dalí had studied the Spanish Golden Age still-lifes at the Prado. Artists such as Zurbarán, Cotán and Diego Velázquez provided the artist with a rich tradition which could serve as a path away from Surrealism. This painting is a clear restatement of his 1926 painting of a bread basket, which had been so well received when it was exhibited. Symbolically, this basket of bread would act as a continuation of his youthful classicism. At this time, the artist was also making a classical half-length portrait of Gala called *Galarina* (1945).

It is worth considering Dalí's move (albeit partial and inconsistent) towards classicism, in the light of the *rappel à l'ordre* (call to order)—also called the *retour à l'ordre*—return to order. In the last years of World War I up until the mid-1920s, there was a reactionary movement (primarily in France and Italy) towards rejecting Modernism and reviving traditional subjects and styles. Dalí's response to the turmoil of World War II and rejection by the Surrealists was to make exactly the same shift as Picasso and the Futurists had done in the late 1910s.

At precisely the same time Dalí was embracing classical still-lifes, another fellow star of the 1920s and 1930s was doing the same. Tamara de Lempicka (1898?-1980) had made her name with scenes of the Roaring Twenties, including liberated women and scenes of conspicuous consumption painted in an Art Deco style. Lempicka and Dalí knew each other and he visited her exhibitions in New York. Both were facing a decline in critical favour and reduced sales. Dalí continued to sustain his income and fame, whereas Lempicka went into a total eclipse. She painted religious and classical paintings, which were coolly received, and later her Surrealist and abstract art was rejected. She ceased painting and her Art Deco scenes were reappraised only shortly before her death.

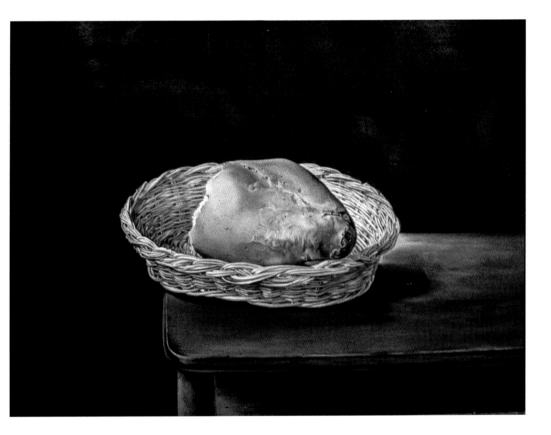

The Temptation of St. Anthony, 1946

Oil on canvas
89.5 × 119.5 cm
Musées Royaux des Beaux-Arts de Belgique, Brussels

St. Anthony the Great (c. 251–356) was a Christian ascetic who went to live in the Egyptian desert. Tradition has it that he was assailed by visions that tested his faith, including being assaulted by monsters and encountering earthly riches. These became the subject of religious paintings from the Renaissance period onwards, with artists inventing new temptations, including visions of delicious food and wine and voluptuous women offering carnal pleasure.

The arachnid-elephants reappear in procession, this time carrying an unclothed temptress, an obelisk, classical buildings with a nude torso and a tower. They are led by a terrifying white stallion with inverted hooves, which threatens to trample the saint, who has only a crucifix to ward off the vision that threatens and tempts him. The meaning of the angel, priest and other figures is unclear; however, the rock upon which St. Anthony supports himself signifies the Christian church founded by St. Peter. The skull represents the mortality of humankind.

This painting was created as a submission for the Bel Ami International Art Competition which took place in 1945/6 and was arranged by the film-producers Loew Levin Company. The competition was for an original painting on the classic Biblical subject of the temptation of St. Anthony, which would be included in the film *The Private Affairs of Bel Ami* (1947). Other entrants included Leonora Carrington, Paul Delvaux, Stanley Spencer, Dorothea Tanning and Max Ernst (the winner). The judges were Alfred H. Barr Jr, Sidney Janis and Duchamp. The paintings were exhibited in September 1946 by the Knoedler Gallery in New York.

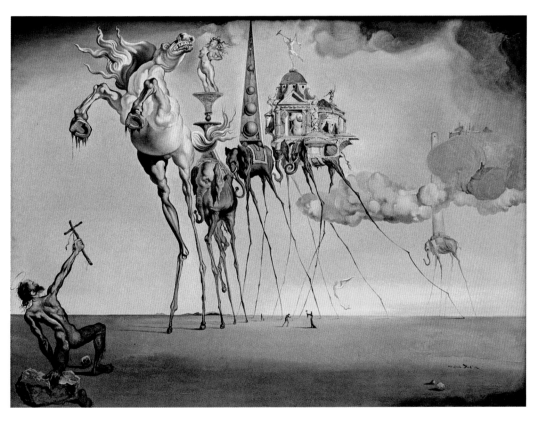

The Madonna of Portlligat, 1949/50

Oil on canvas
275.3 × 209.8 cm
Fukuoka Art Museum, Fukuoka, Japan

Using the floating atomic style of *Leda Atomica* (1947–49), Dalí devised the first work of his religious period, even if *The Temptation of St. Anthony* had been his first religious painting. Gala is the Madonna, on her lap the Christ child with the eucharist inside him. The Christ's hands rest on a globe (the world) and a Bible (the word of God), joining the material and spiritual. Angels in cuttlefish shells hover over a glassy smooth bay at Portlligat, with the earth levitated over the sea. Dalí associated the Mediterranean Sea with the feminine and as the birthplace of civilisation and Christianity. The Madonna is surmounted by a shell and egg (taken from Piero della Francesca's *Madonna and Child*, 1470–75); other attributes include a rhinoceros, an exploding metallic bust, a carnation (symbolising love), a sponge on a cord, a fish, an altar cloth, a shell, an ear of wheat and a liquid splash, among other objects reflecting the artist's uniquely personal cosmology, in addition to traditional symbols. A number of individual painted studies of these objects exist.

When the artist had an audience with Pope Pius XII on 23 November 1949, he brought the painted sketch of this composition to show the pontiff. The pope did not make a public statement about it; Dalí claimed in private that his holiness had approved of the painting. This larger version is considerably more elaborate than the initial one. A first *Madonna of Portlligat* appeared as a drawing in the 1948 book *50 Secrets of Magic Craftsmanship*—a conventionally sentimental and forgettable image. Dalí turned to an assistant to help with the second *Madonna of Portlligat*. Assistants would become more important to Dalí over his last decades.

There is an irony in Dalí's depiction of Gala as the Madonna, the ideal mother. Gala had a distant relationship with her only child, Cécile Éluard (1918–2016). After giving the child to its grandmother to be raised, Gala later often refused to see Cécile and eventually disinherited her.

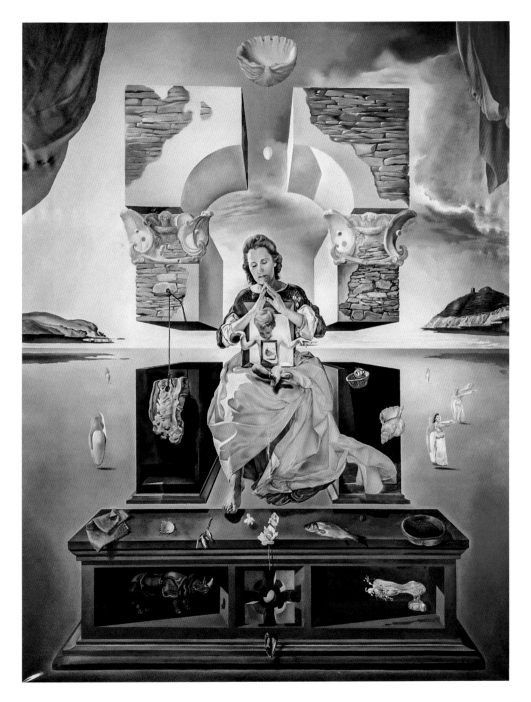

The Christ of St John of the Cross, 1951

Oil on canvas
204.8 × 115.9 cm
Kelvingrove Art Gallery and Museum, Glasgow

The starting point for Dalí's painting was a small ink drawing of Christ crucified
(dated 1577), attributed to Spanish theologian St. John of the Cross (1542–1591),
which positions the viewer above Christ looking down upon his sagging body. The
vertiginous effect of looking upwards but subsequently seeing Christ from above is
highly disorienting, just as the ambiguous lighting leaves us uncertain, imbuing the
scene with a strong supernatural uncanniness. The setting is the beach at Portlligat.
The presence of two fishermen refers to Christ as a fisher of men and the Sea of
Galilee as the site of some of Christ's miracles.

The painting this one most resembles is *Christ Crucified* (1632) by Diego Velázquez
(1599–1660), in terms of the pallor of Christ and the dark background. Dalí revered
Velázquez from a young age. Here Dalí has produced a work of comparable power.
The Christ of St John of the Cross is arguably Dalí's greatest religious painting
and one of his best post-1939 paintings. The triangle of the figure of Christ forms
an assertive arrow, drawing the viewer's gaze down towards the horizon and the
sea. The cross piece of the crucifix and the horizon balance the top and bottom of
the composition, acting to stabilise the picture. The pathos of the depiction, the
dramatic spectacle, beautiful handing of light and attention to detail make this a
masterpiece of devotional art.

The artist rarely went to mass and claimed to have no belief in the afterlife. It has
been noted that Dalí's comments on religion centre on spectacle, wonder, divinity
and miracles, rather than on love, charity and humility and this (for some) limits
the effectiveness of his religious painting. Despite theological unorthodoxy, it is
irrefutable that Dalí's devotional painting is the most distinctive and best known
of all Christian art in the post-War period. In an age of scientific materialism, Dalí's
Christ presents salvation in the non-rational. In Dalí's late religious paintings, the
non-rational is now no longer aberrant and private (as it had been in the Surrealist
period) but is divinely ordained and universal.

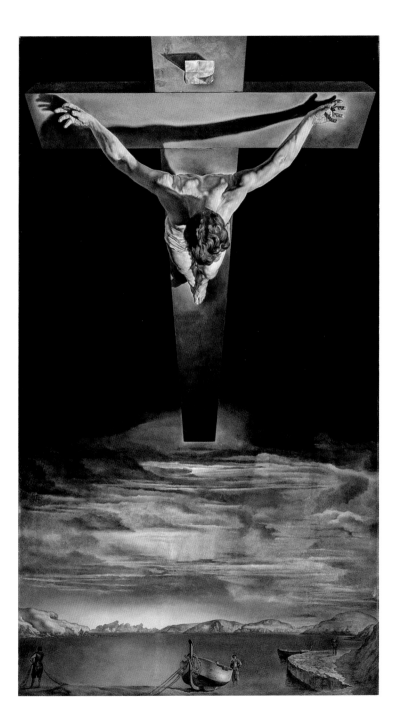

Exploding Raphaelesque Head, 1951

Oil on canvas
43.2 × 33.1 cm
Scottish National Gallery, Edinburgh

In *Exploding Raphaelesque Head* flying angels, rhinoceros's horns and wheelbarrows generate the portrait of an angel or Madonna from the painting of Raphael. The architectural cupola inside the head is based on the Pantheon in Rome. In 1950, Dalí announced his nuclear-mystical period and in April the following year published his *Mystical Manifesto*. It was to counter modern decadence that "comes from scepticism and lack of faith, a consequence of rationalism, positivism and also of dialectical and mechanistic materialism". The nuclear age would inaugurate a revival of faith in Franco's Spain, manifested by a new art movement. Religious mystical art was a natural extension of the principles of Dalí's nuclear period.
"I visually dematerialized matter; then I spiritualized it in order to be able to create energy. The object is a living being, thanks to the energy that it contains and radiates, thanks to the density of the matter it consists of. Every one of my subjects is also a mineral with its place in the pulsebeat of the world, and a living piece of uranium. In my paintings I have succeeded in giving space substance. [...] My mysticism is not only religious, but also nuclear and hallucinogenic. I discovered the selfsame truth in gold, in painting soft watches, and in my visions of the railway station at Perpignan. I believe in magic and in my fate."
Figures and objects in Dalí's late art take on the floating quality of weightless matter. While this does create wonder, it diminishes the materiality of subjects. The compositions become diffuse; the viewer loses a clear sense of the position of motifs in relation to one another. Pictorial space is ambiguous. Sensing that sizes and spatial relationships are indeterminate—indeed, deliberately unclear—viewers engage less with these untethered forms in imprecise space than they do with much of Dalí's earlier work. *Exploding Raphaelesque Head* is painted delicately, full of energy, and has simplicity and grandeur. In it the artist's aerial animation invokes a sense of amazement.

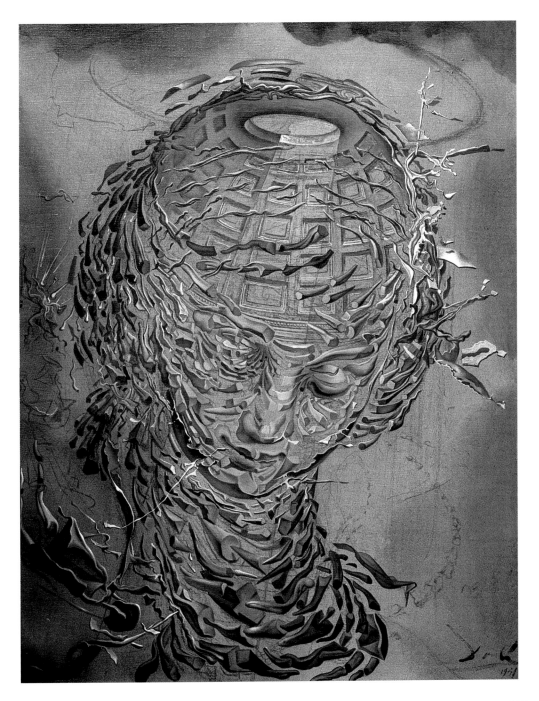

Portrait of my Dead Brother, c. 1963

Oil on canvas
175.3 × 175.3 cm
The Dalí Museum, St. Petersburg (Florida)

"My brother and I resembled each other like two drops of water, but we had different reflections. Like myself he had the unmistakable facial morphology of a genius." Dalí identified with the twins Castor and Pollux, the two offspring born of eggs by Leda after she was impregnated by Zeus in the form of a swan. At different times, the painter identified Gala and Lorca as his semi-divine siblings. Here Dalí paints his dead brother as his twin. The self-mythologising Dalí stated, "My brother died at the age of seven from an attack of meningitis, three years before I was born." In fact, the first Salvador was 22 months old when he died of "infectious gastro-enteric cold", nine months before the artist's birth. The identity of the boy in this painting has not been established.

In *Portrait of my Dead Brother* nucleic molecules suspended over a plain form the visage of the dead child in a half-tone image. Double dots are linked as "twin" cherries with connected stalks. The dots are also the heads of soldiers. Figures from the *Angelus* reconstitute themselves on the ground, apparently unaware of the swarm of soldier nuclei.

Half-tone dots were developed in the 1880s to allow printing of greys consistently in black-only printing systems. Modulated, they suggest shading. They were commonly used in commercial printing—mainly newspapers, journals and comics until the 1970s. Roy Lichtenstein's first Pop Art painting using screen-printed dots was made in 1961 and exhibited in early 1962 in New York. Op art, with patterns of geometric forms, had been going on since the late 1950s. Dalí, who visited New York almost yearly from 1934 until 1979, was very well informed about recent art and attended many exhibition openings, so would have been aware of the new styles.

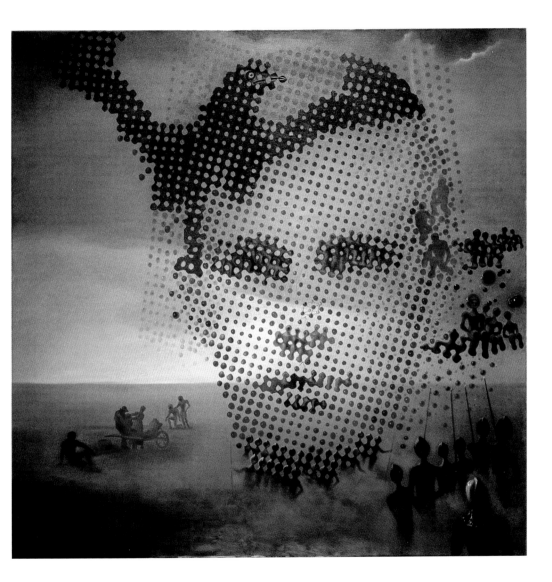

The Hallucinogenic Toreador, 1969/70

Oil on canvas
398.8 × 299.7 cm
The Dalí Museum, St. Petersburg (Florida)

Dalí said that while gazing intently at a box of pencils decorated by an image of the Venus de Milo (c. 150–125 BC), he perceived the head of a bullfighter. He went on to identify the bullfighter as a composite of dead friends, including Lorca. The term "toreador" is not commonly used in Spanish, with *torero* being preferred if a more specific title is not used; "toreador" has connotations of Italian opera. Dalí, however, was not an aficionado of bullfights.

Widely adjudged Dalí's last important painting, *The Hallucinogenic Toreador* is a masterpiece summation of key subjects and approaches from his career—the hallucinogenic-paranoiac double image, classical art, optical patterning, stylistic multiplicity and recurrent motifs. Gala, the boy Dalí, Houdon's bust of Voltaire, a Cubist chair, the Angelus woman, a bull, floating button-flies and Lorca—accompanied by an Andalusian dog—are brought together in a psychedelic encounter between the classical world, modern life and personal memory. Lorca's poem "Lament for the Death of a Bullfighter" (1934) is considered one of his greatest achievements. Dalí had memorised some of Lorca's poems, which his friend had read to him before publication. Luis Romero's book *Todo Dalí en un rostro* (1975) provides a full examination of the painting's iconography.

Dalí's combination of photorealism, Op and Pop Art, allusions to historical art and multilayering of styles has been seen as a precursor of Post-Modernism. Use of technical aides such as photography and overhead and slide projectors to create integrated collages from art and non-art sources likewise looks very contemporary, analogous to computer-generated montages. Screen-printed and hand-painted pictures, from the 1960s to 2010, by Sigmar Polke (1941–2010) are similar to *The Hallucinogenic Toreador*. Curators of the 2012 Paris retrospective of Dalí argued in favour of Dalí's late-period work, but public and critical opinion still favours the Surrealist period.

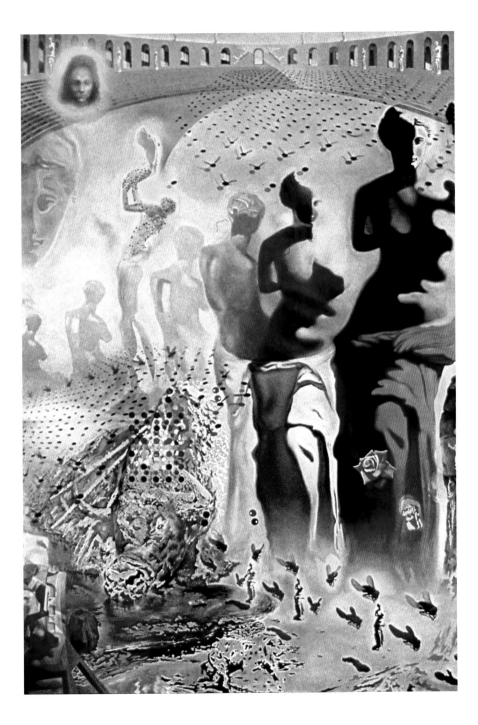

Dalí Seen from the Back Painting Gala from the Back Eternalized by Six Virtual Corneas Provisionally Reflected by Six Real Mirrors, 1972/3

Oil on canvas
60.5 × 60.5 cm
Fundació Gala-Salvador Dalí, Figueres

In 1969 an exhibition of the Dutch painter Gerrit Dou (1613–1675) in Paris inspired Dalí's final creative innovation: stereoscopic painting. He noticed that Dou had painted two versions of many compositions of the same size but with small differences in pictorial detail and became convinced that Dou had used a twin-lensed device to create stereoscopic viewing experiences. (Whether Dou did or not is unknown today.) In the following decade, Dalí produced his own stereoscopic paintings (each to be viewed via lenses and mirrors), many of which also include additional optical effects. This painting is the more finished painting of a pair that were never completed. It appears in a brief sequence in the film *Impressions de la haute Mongolie. Hommage à Raymond Roussel* (1976).

Given Dalí's lifelong engagement with photography, optical devices and—at this time—holographs, it is only to be expected that he would be fascinated by the opportunities and difficulties posed by stereoscopic painting. A cherished boyhood memory was of hours spent staring into a stereoscopic viewer. One image showed a pretty Russian girl on a sledge in the snow. Retrospectively, the artist asked himself, "Was it Gala? I am certain it was." This stereoscopic painting makes a fitting conclusion to this survey of the life and art of Dalí.

The 1970s and early 1980s were not happy ones for the Dalís; legal, financial, emotional and health worries undermined their relationship. While Gala was still at the heart of Dalí's art, reality had become painfully different from the idyllic and magical situations in Dalí's art. Gala spent much of her time in her castle at Púbol and he fretted about the money she spent. In Dalí's hall of mirrors, truth is often hidden or only re-emerges indirectly and unexpectedly. Gala herself remained reticent and enigmatic to the end—secretive and more a fantasy than reality. It was with her death in 1982 that a remarkable body of art came to an end, signed "Gala-Salvador Dalí".

FURTHER READING

Ades, Dawn, and Bradley, Fiona, *Salvador Dalí: A Mythology*, London, 1999

De Burca, Jackie, *Salvador Dalí at Home*, London, 2018

Dalí, Salvador, and Chevalier, Haakon M. (*trans.*), *The Secret Life of Salvador Dalí*, New York, 1942

Dalí & Schiaparelli, Dalí Museum, St Petersburg, Florida, 2017

Homage to Salvador Dalí, Secaucus, New Jersey, 1980

Salvador Dalí, Centre Pompidou, Paris, 1980

Jeffett, William (*ed.*), *Magritte and Dalí*, Brussels, 2019

Descharnes, Robert, and Néret, Gilles, *Salvador Dalí, 1904–1989*, Cologne, 1990; 2006

Gibson, Ian, *The Shameful Life of Salvador Dalí*, London, 1997; 1998

Martin, Jean-Hubert (*ed.*), *Dalí*, Centre Pompidou, Paris, 2012

Schiebler, Ralf, *Dalí: The Reality of Dreams*, Munich, 2005; 2020

Weidemann, Christiane, *Salvador Dalí*, Munich, 2007

PHOTO CREDITS